CHICAGO CUBS

TINKER TO EVERS TO CHANCE

DATE DUE

Dundee Township Public Library District
555 Barrington Avenue
East Dundee, IL 60118-1496
http://www.dundeelibrary.info

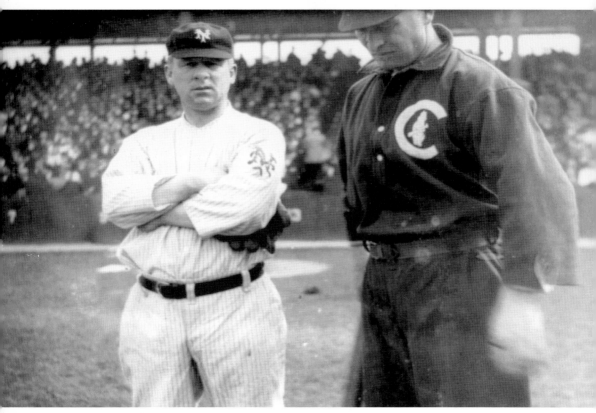

This is a candid photograph from around 1912 that captures Frank Chance (right) with his New York rival John McGraw. Chance was with the Cubs from 1898 to 1912 and as player-manager since 1905. As field boss, his 753 wins to 379 losses mark a .664 winning percentage, higher than any other manager in Cubs history.

On the front cover: Shortstop Joe Tinker is in the foreground. (Author's collection.)

On the back cover: Johnny Evers poses at the home ballpark. (Author's collection.)

Cover background: The 1903 Chicago National League poses for a picture. (Author's collection.)

CHICAGO CUBS

TINKER TO EVERS TO CHANCE

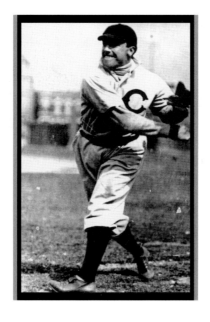

Art Ahrens

ARCADIA
PUBLISHING

Copyright © 2007 by Art Ahrens
ISBN 978-0-7385-5130-2

Published by Arcadia Publishing
Charleston SC, Chicago IL, Portsmouth NH, San Francisco CA

Printed in the United States of America

Library of Congress Catalog Card Number: 2007923973

For all general information contact Arcadia Publishing at:
Telephone 843-853-2070
Fax 843-853-0044
E-mail sales@arcadiapublishing.com
For customer service and orders:
Toll-Free 1-888-313-2665

Visit us on the Internet at www.arcadiapublishing.com

CONTENTS

ACKNOWLEDGMENTS

The author would like to thank the following individuals who were helpful in the creation of this project: Jeff Ruetsche of Arcadia Publishing, without whose able assistance this volume would not have been possible; John Freyer, whose book on Chicago baseball in the 19th century was the catalyst behind this one; Mike, Katie, and the entire gang at Home Tavern and the G&L Fire Escape on Chicago's North Side, their encouragement has been a vital asset; all of my friends in the Old Timers Baseball Association of Chicago (OTBAC) and the Society for American Baseball Research, especially Mark Braun, executive director of the Old Timers; the late Eddie Gold of the *Chicago Sun-Times*, with whom I coauthored five previous books on Chicago Cubs history; the late George Brace, dean of Chicago baseball photographers; my late wife, Susan, whose memory will always be an inspiration to me; my late father, Arthur David Ahrens, who got me interested in baseball when I was a boy in grammar school during the late 1950s. Like my late spouse, he will always be with me in spirit.

Art Ahrens
December 2006

INTRODUCTION

The years between the Spanish-American War and World War I were a colorful and often tumultuous time in American history. The last remnants of the Old West were fading away as Oklahoma attained statehood in 1907, followed by Arizona and New Mexico five years later. While Henry Ford was putting the nation on wheels with the introduction of his Model T in 1908, the nascent motion picture industry—not yet based in Hollywood—was making itself visible. A literary school known as the "Muckrakers" was a prominent influence also. It was a time for the oratory of William Jennings Bryan, the arias of Enrico Caruso, and a larger-than-life president in the person of Teddy Roosevelt.

Popular melodies of the era included "Hello, My Baby" (1899), "In the Good Old Summertime" (1902), "In the Shade of the Old Apple Tree" (1904), "Merry Oldsmobile" (1905), "By the Light of the Silvery Moon" (1909), "Oh, You Beautiful Doll" (1911), "Alexander's Ragtime Band" (also 1911, Irving Berlin's first major success), and the 1908 hit that remains much adored today, "Take Me Out to the Ballgame."

In those days "ballgame" meant baseball and nothing else. Already well established as the national pastime by the 1890s, the game gained unprecedented interest with the inauguration of the World Series between the senior National League and the junior American League in 1903. In 1900, such luminaries as Willie Keeler, Honus Wagner, Nap Lajoie, Cy Young, and Christy Mathewson dominated the diamond. Within a few more years came Ty Cobb, Walter Johnson, Tris Speaker, Eddie Collins, and Grover Cleveland Alexander. And the Chicago Cubs—not always called by that name—were part of the excitement as well.

Following a strong showing in 1898, the Chicago Nationals fell into a period of decline until reemerging as a contender in 1903. Anchored by the infield defense of Joe Tinker at shortstop, Johnny Evers at second base, and player-manager Frank Chance at first base, the Cubs won four pennants and two World Series between 1906 and 1910. Their cumulative winning percentage of .693 remains unequalled for a five-year period. They also boasted a solid pitching staff led by Mordecai "Three Finger" Brown, Ed Reulbach, Carl Lundgren, Jack "The Giant Killer" Pfiester, and Orval Overall.

In 1907 and 1908, the Cubs became the first team to win back-to-back world titles. Sadly, they have yet to repeat. It is the author's and the publisher's fervent hope that the ensuing pages will help recapture a time when the Chicago Cubs were the kings of baseball.

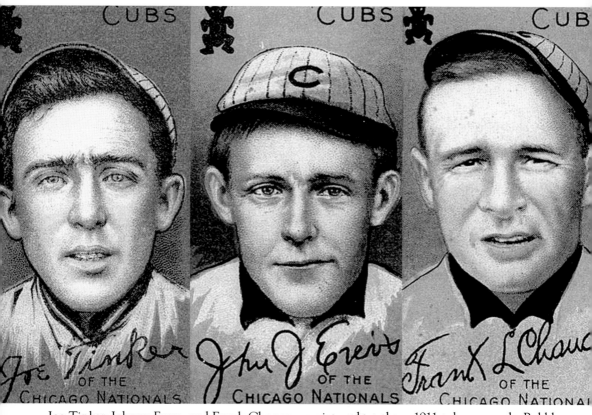

Joe Tinker, Johnny Evers, and Frank Chance are pictured on these 1911 tobacco cards. Bubble gum had not been invented yet. They won four pennants and two World Series together as members of the Chicago Cubs and then entered the hall of fame as the famed "trio of bear cubs" in 1946.

1

THE BEGINNINGS

1898–1901

On February 1, 1898, Chicago baseball fans were given a jolt when the National League club Colts announced that Adrian "Cap" Anson was being released after 22 years as a player and the last 19 as field manager. Replacing him in the latter position was their former infielder Tommy Burns. Anson and Burns had been teammates when the team, then called the White Stockings, won five pennants in seven years between 1880 and 1886.

But as one epoch in the team's history was ending, another was beginning. Recruited by fellow Californian and star outfielder Bill Lange, a 20-year-old Frank Leroy Chance arrived at spring training camp at West Baden Springs, Indiana, on March 8, 1898. Manager Burns liked what he saw, and the young player was hired as backup catcher to regular receiver Tim Donahue.

Chance made his major-league debut on April 29, 1898, for the home opener at Chicago's West Side Grounds. Entering the game in the top of the ninth inning, Chance saw little defensive action and no at-bats in a 16-2 romp over Louisville, then a major-league city. For years it was commonly believed that pitcher Clark Griffith, who thought it was bad luck to pitch a shutout, ordered Chance to drop two pop flies so that a run could score. This is only partially correct. While Griffith was indeed superstitious concerning shutouts, the player he ordered to drop the ball was erratic first baseman Bill Everitt, not Chance. In baseball lore, however, old myths die hard.

Chance did not get to bat until May 11, when he went 0 for 2 against the great Cy Young during a 7-5 loss to the Cleveland Spiders. Despite his inauspicious start, Chance wound up the year with a .279 average in 53 games—not bad for a rookie.

And the 1898 Chicago Orphans were a pleasant surprise, too, finishing a solid fourth (85-65) in the 12-team league, after dragging in ninth the previous year. Pitching was the key to success as the staff's 13 shutouts and 2.83 ERA were both first in the circuit. Griffith savored the greatest season of his career, going 26-10 with a 1.88 ERA, plus four shutouts in spite of his superstition. Jimmy Callahan, in his second full year in the big time, won 20 games. Even Walt Thornton, whose career was otherwise nondescript, fired a 2-0 no-hitter over Brooklyn's Trolley Dodgers on August 21.

Veteran Jimmy Ryan paced the hitting attack with a .323 average, followed by Lange and Everitt, at .319 apiece. Lack of good infield defense, however, was a nagging problem. While most fans resented the firing of Anson, it did not stop them from going to the ballpark in unprecedented numbers as a then-record 424,352 paying patrons entered through the turnstiles

at West Side Grounds. For the first time in history, home attendance had surpassed the 400,000 mark in Chicago.

The future looked bright as the 1899 season grew near. That year spring training was held at a ranch in New Mexico about halfway between Deming and Silver City, and the writers began experimenting with nicknames containing a Western flavor. During that campaign, the newspapers often called them the Cowboys and the Rough Riders, although Orphans remained the primary name.

Off to a quick start, the Orphans were consistently at or near the lead throughout the early part of the year as fan enthusiasm reached a fever level. On April 30, 1899, a paid crowd of 27,489—the largest in baseball annals up to that time—shoehorned its way into West Side Grounds on a damp, humid Sunday afternoon in which additional streetcars were pressed into service to alleviate the foot traffic. Jimmy Callahan, despite surrendering 12 hits, whitewashed the Cardinals, 4-0, on this historic date.

Through July 13, the Orphans were 43-27 and looked like a solid contender. Then came a season-long tailspin as Tommy Burns appeared to be losing control over the team amid dissension within the ranks. The pitching staff showed diminishing results from the previous year. Furthermore, the loss of shortstop Bill Dahlen via an inept trade made an already shaky infield even weaker. As the team declined, so did home attendance. At the end of the year, with the team finishing just two games above the break-even mark, Bill Lange announced his retirement to marry the daughter of a wealthy San Francisco real estate magnate who disapproved of baseball as a means to make a living. Finally, Tommy Burns was axed as manager even though the team's problems were largely no fault of his.

During the winter of 1899–1900, the National League contracted from 12 clubs to 8. With the forgotten Tom Loftus as new manager, Orphans owner Albert Spalding and mouthpiece president James Hart were confident that the team would do better in the shrunken league, but their hopes were ultimately dashed. In a season schedule that was trimmed from 154 games to 140, the 1900 Chicago Nationals finished in a disappointing tie for fifth with the St. Louis Cardinals at 65-75. While the pitching was generally good (the staff ERA of 3.23 was second in the league), they were betrayed by lack of hitting as the team batting average of .260 was last in the circuit. And the defense continued to have more holes than Swiss cheese with a hefty 418 errors, second worst to the New York Giants.

On June 19, 1900—amid this otherwise forgettable summer—Griffith pitched the greatest game of his career, going the distance to beat the Pittsburgh Pirates and Rube Waddell, 1-0, and driving home the winning run with a single in the last of the 14th inning at West Side Grounds. Not long thereafter he renounced his superstition regarding shutouts and ended up leading the league in that arena with four.

When Jimmy Ryan's batting average dropped to .277, the aging outfielder was released near the end of September. As the team's last link to Adrian "Cap" Anson's halcyon days of the 1880s, he was sorely missed. On a positive note, the season's final weeks also witnessed the arrival of catcher Johnny Kling, who would quickly rise to prominence. But as 19th-century baseball in Chicago drew to a close, some extremely rough times were ahead.

The new century brought new problems to the National League as it celebrated its 25th anniversary. The fledgling American League, originally formed in 1895 as the Western League,

a midwestern minor circuit, declared itself a major league in 1901. When the National League refused to recognize its new competitor, the youthful confederation retaliated by raiding the older league's clubs, luring away established stars with plush contracts.

Thanks at least partially to the tight-fisted salary policies of Spalding and Hart, the Orphans were hit hard by the raids. No less than seven players from the 1900 roster, most of them regulars, jumped to the American League in 1901. To make the affair even more embarrassing, three of the their former stars—Jimmy Callahan, Griffith, and Sam Mertes—were playing for Charles Comiskey's pennant-bound Chicago White Stockings (soon to be shortened to White Sox) on the city's South Side and taking large numbers of fans with them.

Their ranks decimated, the Orphans were quickly relabeled the "Remnants," an appropriate appellation for the hastily assembled collection of has-beens and never-weres that represented the club in 1901. They finished the season in sixth place with only 53 wins against 86 losses, for a .381 percentage to remain the team's worst until 1962, during the ill-fated "College of Coaches" era.

The club was also losing money hand over fist with a low turnout at the ballpark. Clearly a massive house cleaning was needed, and the sooner the better.

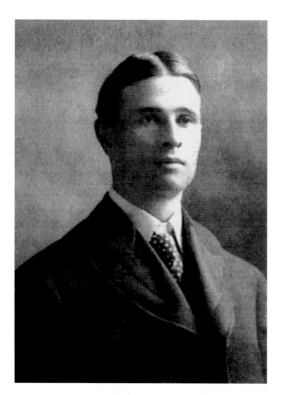

The youthful Frank Chance is seen here as a rookie catcher for the Chicago National League club in 1898. His best years were far ahead of him. When Chance made his major-league debut on April 29, 1898, the hurler he caught was Clark Griffith, pictured below. (OTBAC.)

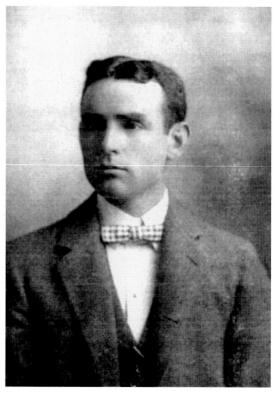

Griffith joined the Chicago Colts at the end of 1893 and was a 20-game winner for six straight seasons from 1894 through 1899. This performance has been equaled by only two Cubs pitchers—Mordecai Brown (1906–1911) and Fergie Jenkins (1967–1972). (OTBAC.)

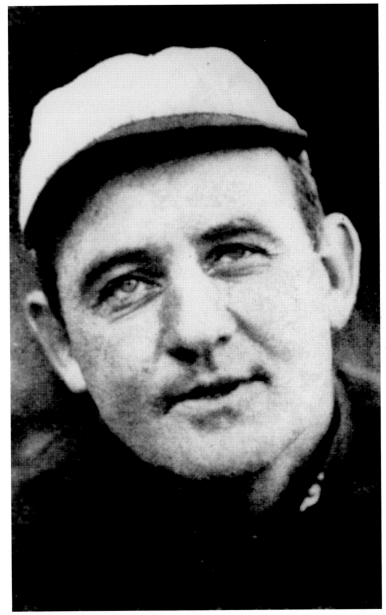

Jimmy Callahan pitched and played utility for the Cubs when they were called the Colts and later the Orphans (1897–1900). He was a 20-game winner in 1898 and 1899 and then jumped to the American League White Sox in 1901. He threw the first no-hitter in White Sox history on September 20, 1902, blanking the Detroit Tigers, 2-0. In 1906, Callahan, having left the majors, formed his own semiprofessional team in Chicago's Logan Square neighborhood. It was here, after the 1906 World Series, that he savored his most sublime triumph, taking the mound to defeat the American League champion White Sox 2-1 one day and playing outfield and delivering the game-winning single for his team in a 10-inning, 1-0 defeat of the National League champion Cubs the next.

Sidearmer Jack Taylor made a spectacular debut with the Orphans in late 1898, winning and completing all five of his starts. But it was under Frank Selee's guidance that Taylor fully blossomed as a pitcher, winning 22 games in 1902 and 21 the year after. He was traded to the St. Louis Cardinals, however, amid rumors that he had thrown games against the Chicago White Sox in the 1903 City Series. It was the deal that brought Mordecai Brown to the Cubs.

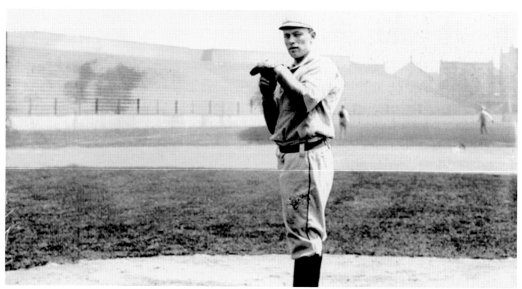

Taylor fortunately returned to Chicago in 1906 to post a 12-3 record down the stretch as the Cubs won a record 116 games. Frank Chance, by then manager, liked Taylor personally and wanted to use him in the World Series but feared that if Taylor pitched and lost, the game-throwing charges would resurface. Taylor sat on the bench. He was released late the following year. From June 20, 1901, through August 9, 1906, the sidearmer was not relieved once in 187 starts—a baseball record destined to stand forever.

Still called the Colts at the start of 1898, the ball club became the ex-Colts when Adrian "Cap" Anson was hired to manage the New York Giants. Since a number of early season games were rained out, they were also known briefly as the Rainmakers. Both names died out quickly, however, as sportswriters soon settled on Orphans, which seemed appropriate following the loss of their "father," Anson.

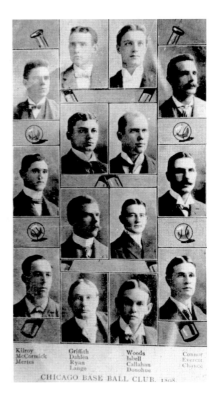

Kilroy Griffith Woods Connor
McCormick Dahlen Isbell Everett
Mertes Ryan Callahan Chance
 Lange Donohue

CHICAGO BASE BALL CLUB. 1898

Everett Mertes Gar
Lange Chance Don
Wolverton Griffith M
Ryan Callahan

CHICAGO BASE BALL CLUB. 18

The 1899 Orphans started out well but floundered, finishing 75-73. The fellow in the jaunty fedora is outfielder Sam Mertes, who led the team in home runs with nine. Callahan and Griffith were each 20-game winners (the latter for his sixth straight year), but the others were inconsistent. Edward "Danny" Green, Bill Lange, and Jimmy Ryan joined Mertes with fine seasons at the plate, but they could not prevent the Orphans from tumbling to eighth place in the 12-team league.

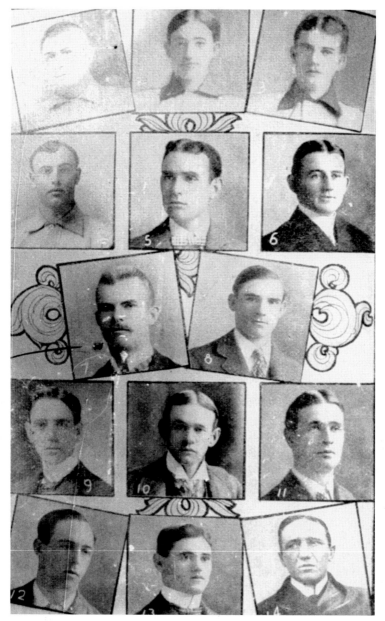

This compilation of the 1900 Orphans, a team that finished 10 games below .500, looks more like a rogues gallery of police suspects than a professional baseball team. And their home ballpark, West Side Grounds—bounded by Wood Street on the east, Wolcott Avenue (then called Lincoln Street) on the west, Polk Street on the north, and Taylor Street on the south—could become quite the raucous place. On the Fourth of July 1900, during the afternoon game of a doubleheader against Philadelphia, roughly 1,000 fans (out of a crowd of 10,000) were armed with revolvers and began firing them in the air, putting numerous holes in the wooden roof. Fortunately, the Orphans won both games; otherwise there might have been a bullet-riddled umpire as well. Such were the gun-toting Chicago baseball fans of long ago.

Orphans pitcher John "Jocko" Menefee was on the team from 1900 through 1903. In 1902, his 12 wins were tied for second highest on the staff, but beyond that, his accomplishments were negligible.

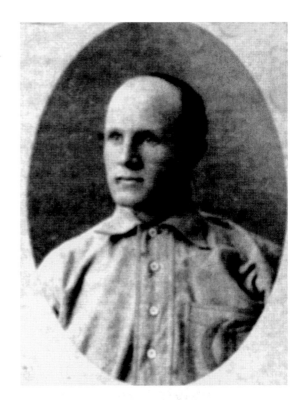

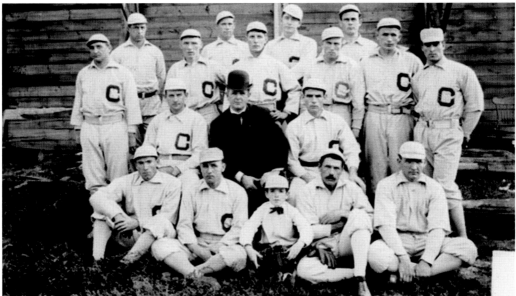

The Cubs' first genuine competition for the adulation of Chicago baseball fans were the original pennant-winning White Sox of 1901, pictured here with owner Charles Comiskey seated in the center. Three of their star players—Sam Mertes (third row, second from right), Clark Griffith (seated to Comiskey's right), and Jimmy Callahan (seated to Comiskey's left)—had been with the Cubs the previous year. (OTBAC.)

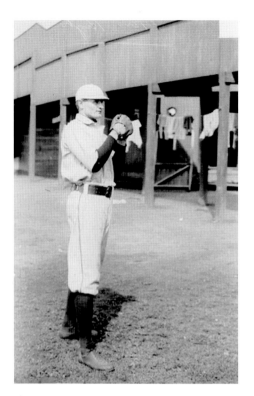

Southpaw George "Rube" Waddell, whose lone season with the Orphans was 1901, posted a club best 13-15 record for a horrendous Chicago team that went 53-86. Despite his 168 strikeouts and 2.81 ERA, the organization soured on Waddell's hard drinking and erratic behavior and shipped the future hall of famer out at season's end.

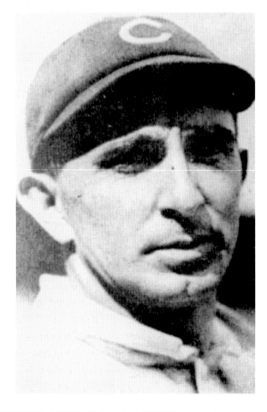

Catcher Johnny Kling, seen here in later years, joined the Orphans in September 1900. He batted .294 and showed exceptional skill with the glove for the disappointing fifth-place ball club. Kling would soon emerge as the premier receiver in the National League, his best season being 1906, when he batted .312. After two more pennants, Kling won the World Pocket Billiard Title in the winter of 1908–1909 and decided to sit out the upcoming baseball season in favor of the cue stick before returning to plate duties for Frank Chance's pennant-winning Cubs of 1910.

2

BUILDING A CHAMPION

1902 – 1905

Replacing Tom Loftus as manager for the 1902 season was Frank Selee, just coming off a successful 12-year reign as field boss of the Boston Beaneaters (Braves), winning five pennants. Although already ailing from tuberculosis (then still commonly called "consumption"), it was not yet affecting his ability to run a team. Selee emphasized youth in his rebuilding program; hence a new name, the Cubs, began to catch on, although Colts was the more common name at this point.

The team, which would soon become a powerhouse, began to coalesce in earnest. Jimmy Slagle, whom Selee had brought with him from Boston, was given the left field position and did a magnificent job. Rookie Joe Tinker nailed down the shortstop slot immediately, never to relinquish it. Upon his graduation from University of Illinois in June, Carl Lundgren emerged as a valuable addition to the pitching corps. Jack Taylor finally lived up to his potential with 22 wins, eight shutouts, and a league-leading 1.33 ERA. And catcher Johnny Kling, in his first complete season, was coming into his own both with his glove and his bat.

Meanwhile, now in his fifth year with the Colts, Frank Chance appeared doomed to be a career backup man to Kling. Late in the season, however, Selee ordered him to concentrate on playing first base rather then catching. Against his own will, Chance accepted the command. Little did he know it would be the turning point of his career.

In early September, 21-year-old Johnny Evers joined the Colts to aid the aging Bobby Lowe at second base. On September 14, 1902, the first Tinker to Evers to Chance double play was recorded during an 8-6 loss to the Cincinnati Reds at West Side Grounds. The second came the following day against the same team in a 6-3 Colts win with Carl Lundergren on the mound, as a new era in Chicago baseball was taking shape. Although the Colts finished fifth at 68-69, it was still a vast improvement over the previous campaign, and Frank Selee was pleased with the results.

By 1903, the Tinker-Evers-Chance trio was getting into full swing to give the Colts their best front line defense since the heyday of the "stonewall infield" in the 1880s. With a league-tying 67 stolen bases and a .327 batting average, Chance had finally found himself. Evers, in his first full year, batted .293, while Tinker hit .291. At third base was James "Doc" Casey, so nicknamed because he was a dentist during the off-season. While not an exceptional third baseman, Casey caused no harm at the position either and held it down through 1905.

Team pitching was getting tougher as the 1903 Colts boasted 20-game winners Taylor (21-14) and rookie Jake Weimer (21-9) with Bob Wicker, another newcomer, right behind at 19-10.

The staff ERA of 2.77 was at the top of the National League totem pole. More importantly, the Colts soared to third place to make them a bona fide contender for the first time since 1891. Concurrently, fiery manager John McGraw was turning the Giants into a winner as a heated Chicago-New York rivalry was starting to develop. With a winning team to root for, fans began returning to West Side Grounds in large numbers. The Colts paid attendance of 386,205 put the club's finances back in black ink for the first time in four years.

On December 12, 1903, pitcher Taylor and catcher John McLean were traded to the Cardinals for pitcher Mordecai "Three Finger" Brown and catcher Jack O'Neill, in a deal that would work wonders for the Colts.

Because of escalating fan interest, the 1904 baseball schedule was increased back to 154 games from 140. Pitching was now by far the dominant force in the game due to the foul strike rule and the invention of trick pitches such as the spitball, shine ball, and emory ball, all of which would be outlawed in 1920. In 1904, the cumulative batting average of the National League dropped to .249, a decrease of 20 points from just a year earlier.

The acquisition of Brown bolstered a Colt pitching crew that was already one of the strongest around. Brown had lost his right index finger in a childhood accident, but the alleged handicap gave him a natural sinker ball plus a devastating curve. Weimer and Wicker continued to be hard to beat, while Carl Lundgren began to hit his stride, winning 17 games. A recycled Herb "Buttons" Briggs, who had previously pitched for Adrian "Cap" Anson in 1896 and 1897, was a pleasant surprise with a 19-11 log. Now having to take time off periodically for health reasons, Selee appointed Chance as a team captain and began teaching him the tricks of the managerial trade. Chance was beginning to have medical problems of his own. His beanings from crowding the plate (including five in a Memorial Day doubleheader versus the Reds) were on the rise, resulting in migraine headaches and increased trips to Cook County Hospital near the home grounds.

Nevertheless, Selee's Colts and McGraw's Giants battled for supremacy in May and June as the rivalry intensified. On June 11, 1904, undefeated New York ace Joe McGinnity was going for his 13th win of the year. Facing him was Chicago's Bob Wicker, before a then-record throng of 38,805 at the Polo Grounds. Wicker held the Giants hitless for nine innings, allowed harmless singles to Art Devlin and former Colt Sam Mertes in the 10th, and then no-hit them again before winning in the 12th, 1-0, on Johnny Evers's single. Even the New York fans were impressed, and a crowd carried Wicker to the visitors' clubhouse on their shoulders.

New York surged well ahead thereafter, and Chicago had to be content with a second-place finish, 13 games behind despite an impressive 93-60 record. Signing with the Colts at the end of the year were rookie outfielder Frank "Wildfire" Schulte and utility man Artie "Solly" Hofman, both of whom would have productive futures.

Favorably impressed with Schulte's play, Selee selected him to be his regular left fielder in the spring of 1905, pushing Jimmy Slagle to center. It was also at this time that Selee made his last major signing, that of freshman pitcher Ed Reulbach. Reulbach won a berth on the starting rotation at once and did not disappoint. On June 24, 1905, he went the distance to edge former Colt Jack Taylor of the Cardinals, 2-1, in 18 innings. Exactly two months later, on August 24, he again went the distance to defeat Tully Sparks of the phillies, 2-1, in 20 innings. For the season, Reulbach was 18-13 as his win total tied Brown and Weimer for the team lead.

But as Reulbach and Schulte were becoming new heroes, Frank Selee was fighting a losing battle with failing health. By June 1905 he was no longer able to make road trips, having Chance fill in for him. His lungs ravished with tuberculosis, Selee resigned on August 1 in favor of the former catcher he had converted to a first baseman. He soon relocated to Denver, where he died four years later of the then-incurable disease.

Not long after Chance became manager, James Hart sold the club to Charles Murphy, whose relationship with Chance would always be a strained one. Nevertheless, when Chance assumed control of the Cubs, they were in fourth place with a 52-38 record. Under his leadership, they won 40 of 63 to finish a strong third at 92-61. But third place did not satisfy Chance, as significant changes were in the wind.

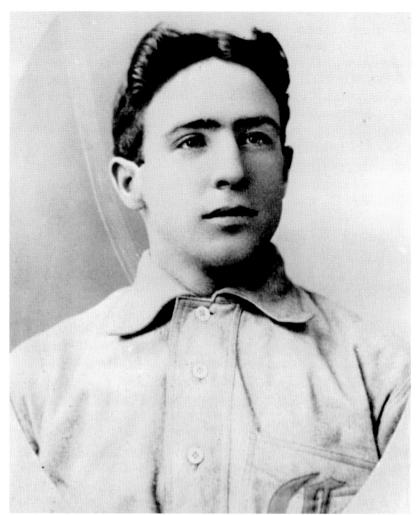

A handsome Joe Tinker is depicted in 1903, his sophomore season with the Colts. He fast became a fan favorite. As the regular shortstop from 1902 through 1912, Tinker was an outstanding glove man, leading the league in fielding percentage four times, assists three times, total chances per game three times, putouts twice, and double plays once. Tinker grew more proficient at the plate in his later years and was always dangerous in the clutch. He was traded to the Reds for the 1913 season and jumped to the Federal League Chicago Whales the following year. As player-manager, Tinker led the Whales to the pennant in 1915. When that league disbanded, he returned to the Cubs as manager in 1916 and played in but a handful of games. He retired at season's end a .263 lifetime hitter with 336 stolen bases.

The year 1903 was second baseman Johnny Evers's first full season with the Colts, after joining them the previous September. Like infield partner Tinker, Evers was a daring base runner, fine fielder, and usually a light batsman but dependable in pressure situations. Although Tinker and Evers did not speak to each other for several years, they performed like clockwork on the diamond and were a key factor in the Cubs winning four pennants and two World Series between 1906 and 1910.

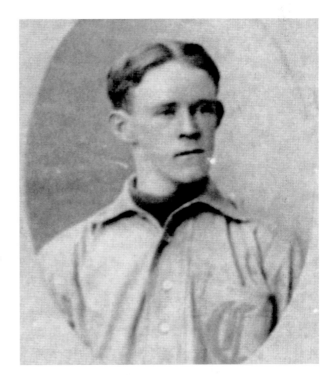

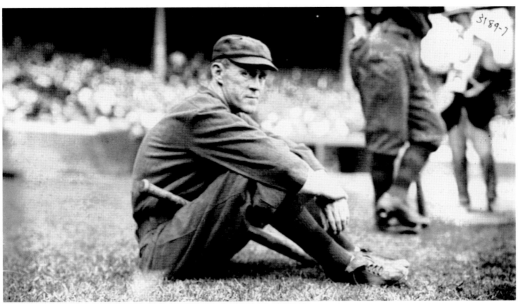

Nicknamed the "Crab" because of his generally sour disposition, Evers was not the easiest person to get along with. Nevertheless, he was all ballplayer from the ground up, making the most of journeyman-level abilities. He served his final season with the Cubs as player-manager in 1913 and was dismissed after one season. Evers was a .270 lifetime hitter who enjoyed two .300 seasons with the Cubs (.300 in 1908 and .341 in 1912) and won another World Series with the 1914 Boston Braves.

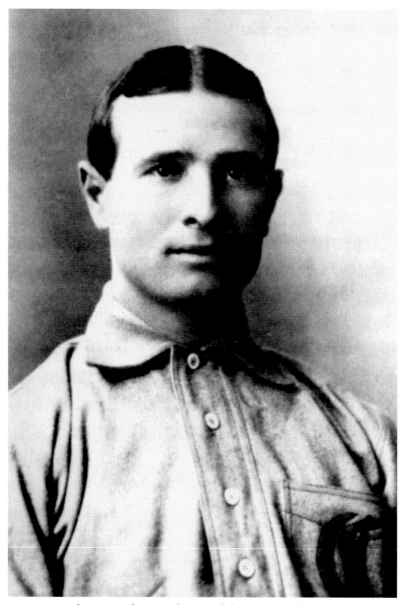

Frank Chance remained stationed at catcher until late 1902, when new skipper Frank Selee ordered him to man first base instead. Beginning in 1903, his sixth season with the team, Chance enjoyed four straight .300-plus years at the plate as he learned to like his new position. A fierce competitor who routinely got on base by crowding the plate in defiance of the pitcher and getting beaned, he was often at or near the top of the league in stolen bases. In 1905, Chance would replace the ailing Selee as manager. He would go on to amass a seven-plus year winning percentage of .665, highest in the Cubs annals, after they blew a 5-0 lead and lost to the lowly Philadelphia Phillies, 7-6, in his debut at the helm. Nicknamed the "Peerless Leader," it was as a player-manager that Chance savored his greatest success, winning four pennants from 1906 to 1910 with two World Series wins sandwiched between.

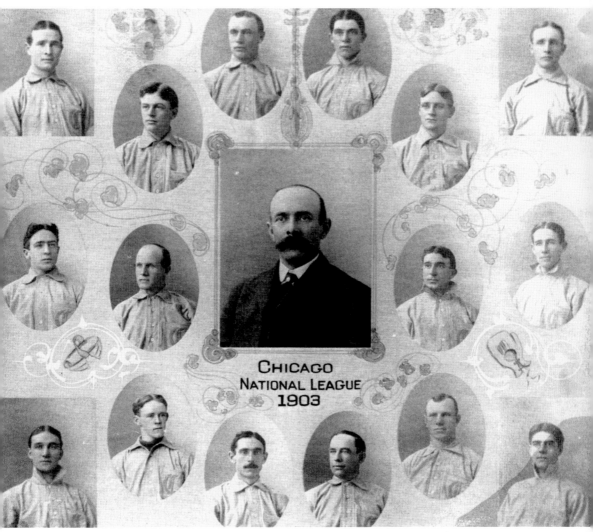

CHICAGO
NATIONAL LEAGUE
1903

This composite of the 1903 team includes many portraits taken the previous season. Simply labeled Chicago National League, "Cubs" was now challenging "Colts" in popular usage. The *Chicago Tribune*, which had the largest circulation, took the lead in reviving the old name, remarking on April 17, 1902, that "the present team is more generally composed of Colts then any which carried that name in Anson's day." The *Sporting Life*, published in Philadelphia, called the team the Cubs while the St. Louis–based *Sporting News* used Colts instead. But since Frank Salee preferred the established name to the new one, the club was more commonly known as Selee's Colts during his managerial tenure, with Cubs being the secondary name. Other monikers, such as Recruits, Panamas, and Zephyrs, would pop up from time to time also. All were short-lived. The center portrait is the distinguished-looking Frank Selee, Colts manager from 1902 until August 1, 1905, when he resigned for health reasons. He turned the Colts from a laughing stock to a contender in less than two years. Perhaps most significantly, he made Chance become a first baseman. Selee never played an inning of major-league ball, yet his election to the hall of fame in 1999 was long overdue.

The Chicago National League club of 1903 finished 82-56, in third place behind the Pittsburgh Pirates and runner-up New York Giants. Manager Frank Selee, in civilian dress, is seated at center. Catcher Johnny Kling (top, second from right) had his finest overall season, batting .297 with career highs for hits (146), doubles (29), triples (13), runs scored (67), RBI (68), and stolen bases (23). He also led the league in putouts with 499. Bob Lowe (middle row, far left) was the

CHICAGO CUBS

Colts regular second baseman in 1902 but was relegated to the bench when he broke his knee the following spring, which allowed Evers to take over the position. For trivia buffs, he was also the last Cubs player to wear a mustache on the field until Billy Williams broke the mold in 1970. (National Baseball Hall of Fame and Museum.)

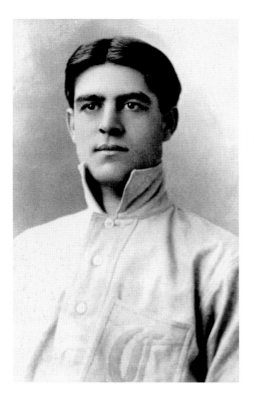

Colts pitcher Jake Weimer, although nearing 30 years of age, was a rookie sensation in 1903. As a freshman he posted a 21-9 record with a 2.30 ERA, which was the best on the staff. Not bothered by the "sophomore jinx," he won 20 games the following year. Called "Tornado Jake" for his blazing fastball, Weimer posted another fine season (18-12) in 1905 before being swapped to Cincinnati for third baseman Harry Steinfeldt.

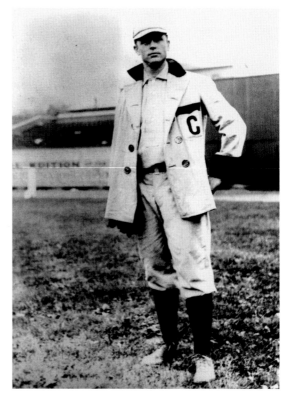

Bob Wicker was a key pitcher for the Colts during their rebuilding years, winning 19 games in 1903, 17 in 1904, and 13 in 1905. On June 11, 1904, he held the New York Giants hitless for nine innings, allowed two singles in the 10th, then held them hitless again in the 11th and 12th, finally winning 1-0. (Brace.)

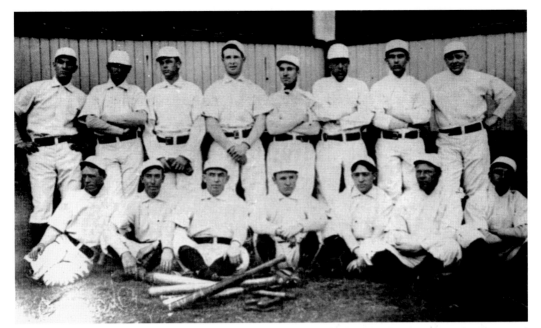

The 1904 Colts, seen here in rather drab-looking uniforms, inched their way up the National League ladder to second place, still 13 games behind the pennant-winning Giants as the New York-Chicago rivalry began to heat up. By now, the team's main exponents were pitching, speed, and defense as low-scoring games were fast becoming the rule.

In 1905, the Colts slipped to third place, but with a record (92-61) almost identical to the previous year. The nickname Cubs was beginning to surpass Colts in popularity after Frank Chance assumed managerial duties.

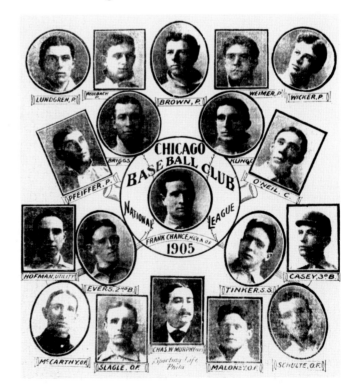

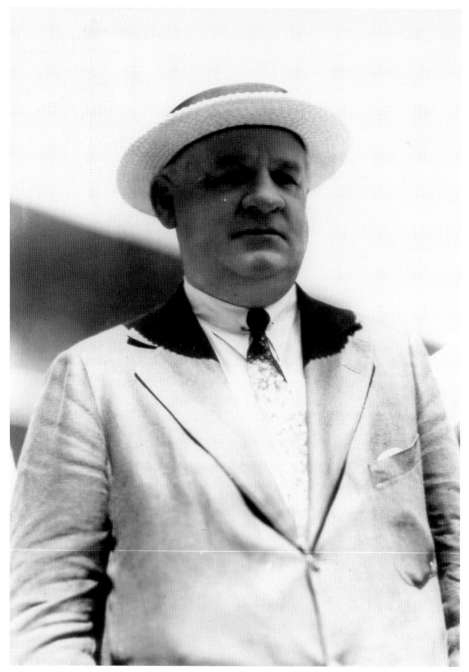

Feisty Giants manager John McGraw, pictured here in civilian clothing, was the archenemy of Cubs fans during the Tinker-Evers-Chance era and for many years to follow. Although a cantankerous individual, there were no doubts concerning McGraw's abilities as a manager. Nicknamed "Little Napoleon" and "Mugsy," he led the Giants to 10 pennants and three World Series titles during three decades at their helm, and rarely fielded a losing team. Many players he tutored wound up in the hall of fame, as did McGraw himself. (Brace.)

Jimmy Slagle was a mainstay in the Cubs outfield from 1902 through 1908. His first two years in Chicago were his best at the plate, batting .315 with 40 steals in 1902 and .298 with 33 swipes the following season. Sporting three nicknames, "Shorty," the "Rabbit," and the "Human Mosquito," Slagle remained an asset to the Cubs for his defensive and base-running skills, even though his hitting tapered off after 1903. He had to quit baseball in August 1908 for medical reasons, he was a lifetime .268 batter with 273 stolen bases.

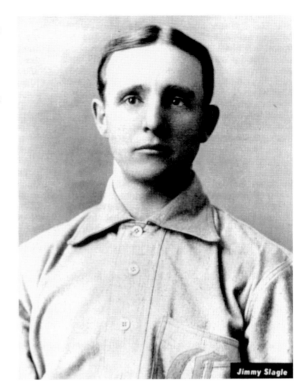

Jimmy Slagle

Pitcher Carl Lundgren joined Frank Selee's Colts in June 1902. He was especially effective in cold weather; hence his nickname, the "Human Icicle." Lundgren had his best seasons with the 1906 and 1907 flag winners, going 17-6 and 18-7, respectively. In 1907, he posted an incredible 1.17 ERA while hurling seven shutouts. Why Frank Chance never pitched Lundgren in World Series play remains a mystery. After slumping in 1908, he was released early the next year to become a legendary college baseball coach in the Big Ten.

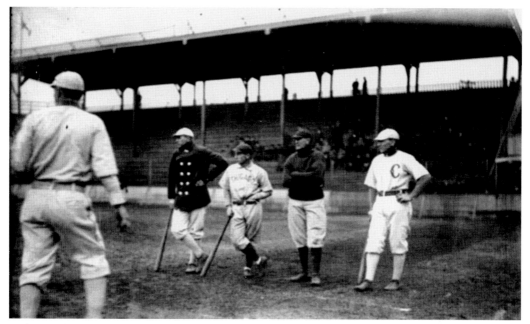

Cubs catcher Johnny Kling and White Sox second baseman Frank Isbell appear with three unidentified other players at South Side Grounds during the 1905 postseason City Series. The Cubs won it in five games.

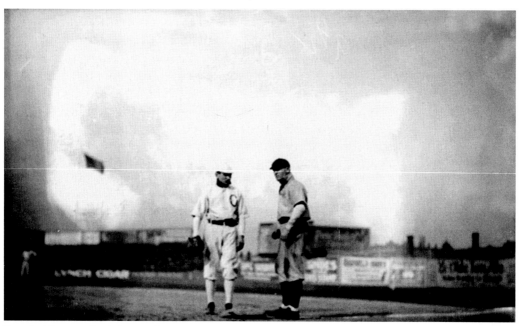

Frank Chance (right) stands safely at first base during the 1905 City Series at South Side Grounds, home of the White Sox. At Chance's left is White Sox first baseman Jiggs Donahue, an outstanding glove man. The two teams would be playing for much more than bragging rights the following postseason.

3

CROSSTOWN CLASSIC

1906

The team that most personified the Cubs of Frank Chance entered into its definitive form during the winter of 1905–1906. Third baseman Harry Steinfeldt was acquired from the Reds and outfielder Jimmy Sheckard from the Brooklyn Superbas. Scheckard would be stationed in left field as Frank Schulte was switched to right. They also obtained Pat Moran, who became a dependable backup catcher to Johnny Kling. Pitching was given yet another boost with the addition of much-needed left-hander Jack Pfiester. In mid-1906, it was fortified still more by the addition of Orval Overall from the Reds and the reacquisition of Jack Taylor from the Cardinals.

The result was an unstoppable juggernaut that laid all opposition to waste. In capturing their first flag in 20 years, the Cubs led the league in batting (.262), runs scored (705), slugging average (.399), fielding average (.969), strikeouts by pitchers (702), shutouts (31), and ERA (1.76). They tied for the lead in triples with 71, while their 194 errors set a new low in that era of small, under-padded gloves. Their 283 stolen bases—including a league-tying 57 by Chance and 49 by Johnny Evers—remain a city record. The pitching featured four one-hit games, two by Brown and one each by Pfiester and Ed Reulbach. Steinfeldt batted .327, Chance .319, and Kling .312. Joe Tinker and Evers, while not hitting for high average, were dangerous in the clutch. And with the team playing better then ever, home attendance zoomed to 654,300.

Yet there were actually no full-fledged superstars in the club, with the possible exception of Brown, who won 26 games. They were simply a collection of good journeyman ballplayers that jelled as a unit. Deservedly much of the credit for the Cubs' success went to player-manager Chance, whose relentless aggressiveness on the diamond set a powerful example for the team.

In the meantime, the White Sox were surprise winners of the American League pennant, largely on the impetus of a 19-game winning streak in August. Like the Cubs, the White Sox boasted an outstanding pitching staff in the arms of Ed Walsh, Nick Altrock, Guy "Doc" White, Frank Owen, and Roy Patterson. Their 32 shutouts have been equaled only once, and never exceeded.

When it came to batting, however, the White Sox appeared to be on life support. Dubbed the "Hitless Wonders", they posted an anemic .230 team batting average with seven home runs, the same total as Cubs leader Frank Schulte. They finished at 93-58 for a .616 percentage, impressive but hardly earthshaking. Their only hitters above .260 were second baseman Frank Isbell at .279 and shortstop George Davis at .277. The second-place New York Highlanders (Yankees) pulled in just three games out.

As World Series time approached, the Cubs were three-to-one favorites with the oddsmakers, especially since they had creamed the White Sox in five games during the 1905 City Series. Business in Chicago came to a near halt on October 9, 1906, the opening day of the World Series. Alderman Bathhouse John Coughlin got city hall closed down so that his payrollers could attend the games. For the moment, nothing else in the world mattered to baseball-minded Chicagoans.

Both clubs agreed that the series games would alternate from West Side Grounds to the White Sox's South Side Grounds at Thirty-ninth Street and Princeton Avenue. Both parks were constructed entirely of wood, making it easy for freeloaders to climb in over the back fence.

Snow flurries, a bitter wind, and 30-degree temperatures chilled the players and fans during the World Series opener at West Side Grounds. The inclement weather limited attendance to 12,693 frosty fans, most of them clad in winter overcoats and gloves. The first game was a pitching connoisseur's delight as the White Sox's hard-throwing Nick Altrock bested Mordecai "Three Finger" Brown and the Cubs, 2-1. Each pitcher allowed a scant four safeties.

The teams moved to South Side Grounds for the second contest. Cold weather again hurt attendance as just 12,595 showed up. This was to be the high point of the World Series for the Cubs, as Ed Reulbach slammed the door on the White Sox, 7-1, allowing one lone hit. The batting heroes for the Cubs were Harry Steinfeldt with three hits in as many at-bats and Joe Tinker, who ripped two hits and scored three runs.

It was then back to the West Side Grounds for game three. The weather moderated somewhat as attendance inched up to 13,667. Seated in one of the boxes were 19th-century Cubs stars Adrian "Cap" Anson, Jimmy Ryan, and Fred Pfeffer. In fashioning a two-hitter, White Sox spitballer Ed Walsh fanned a then-record 12 Cubs as his teammates coasted to a 3-0 victory over Jack Pfiester. Again the surprising White Sox had taken the World Series lead. Significantly, the venerable Anson remarked "that victory makes the chances of the White Sox rosier."

Altrock and Brown faced each other again the next day as the fourth game proved to be the best pitched of the World Series. In a contest that lasted only one hour and 36 minutes, Brown allowed two hits in edging his opponent, 1-0, before an unhappy White Sox crowd of 18.385. The winning run came in the seventh when Evers sent Chance home with a single to even the World Series at two games apiece.

On a warm, sunny Saturday, October 13, an overflow crowd of 23,257 jammed their way into West Side Grounds to witness the crucial fifth game. Several thousand were turned away, and ticket scalpers were getting as much as $20 for a single admission—a hefty price in an era when many workingmen barely earned that much in a month.

Unlike the first four games, Game 5 featured little pitching skill from either team. In a sloppily played affair on both sides of the fence, the White Sox outlasted the Cubs, 8-6, despite making six errors. Walsh pitched the first six White Sox innings and earned the win, while Pfiester, in relief of Reulbach, was charged with the loss, his second of the World Series. For the first four games, neither team had been able to win at home. For the fifth game, Chance had the Cubs decked out in their gray road uniforms, hoping to break the jinx. It was to no avail.

The next day the action switched back to Thirty-ninth Street, as a standing-room-only throng of 19,249 packed the rafters of South Side Grounds. Brown was making his third start for the Cubs, this time against White.

In the second half of the first inning, the Cubs held a 1-0 lead. White Sox runners were on first and second base with one out. White Sox shortstop George Davis then doubled to right field, scoring player-manager Fielder Jones from second. It was Davis's blow that shattered the Cubs psychologically (Cubs right fielder Frank Schulte was prevented from making the out by fan interference, he claimed, and manager Chance fruitlessly disputed the play). The White Sox went on to take a 3-1 lead, then scored four more in the second inning to make it 7-1.

For all practical purposes, the game and the World Series were history. The demoralized Cubs tallied single runs in the fifth and ninth innings, while the White Sox put another across in the eighth to make the final score 8-3. The underdog White Sox had won the World Series.

Chance admitted defeat only with reluctance: "The Sox played grand, game baseball and outclassed us in this series . . . But there is one thing that I will never believe, and that is that the White Sox are better than the Cubs."

Although Chance was obviously biased on his team's behalf, he was probably correct. The White Sox would not repeat as champions until 1917, while the Cubs were on the verge of a dynasty.

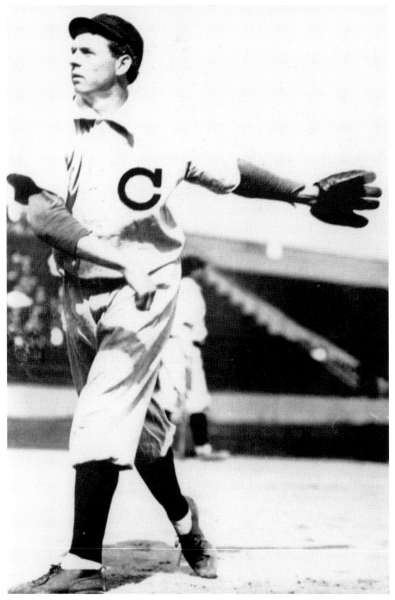

Pictured here in 1906, pitcher Mordecai "Three Finger" Brown was obtained by the Cubs from the Cardinals two years earlier. It was a childhood farming accident that turned Brown into one of baseball's greatest pitchers. At age five, his right hand got caught in a corn shredder, the subsequent disfiguring of which led to Brown's natural development of a sinker as well as a curve ball that broke down and out, forcing batters to slap the ball into the ground. Following two good seasons, Brown burst into superstardom in 1906 with a 26-6 ledger, nine shutouts, and a league-leading 1.04 ERA. At the height of the Cubs-Giants rivalry, Brown was often pitted against New York ace Christy Mathewson, beating the "Big Six" in 13 of 24 decisions. He retired in 1916 with a lifetime 239-129 record, a miniscule 2.06 ERA, and 57 shutouts. Brown's 188 wins as a Cub are second only to Charlie Root's 201. He was named to the hall of fame in 1949.

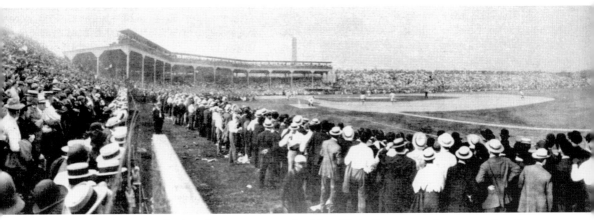

The Cubs lock horns with their bitter enemies, the New York Giants, in this view taken from the right field line at West Side Grounds on August 18, 1906. The Cubs won, 6-2, Mordecai Brown over Christy Mathewson. But the most satisfying victories of the season had come at the Polo Grounds in June, when not only did the Cubs take three straight, they utterly humiliated the mighty men of John McGraw with a 19-0 whitewash on June 7 behind Jack "the Giant Killer" Pfiester. Mathewson, the pride of New York, was shelled out in an 11-run first inning. McGraw never forgot this shattering defeat, nor did Cubs fans let him live it down. For the rest of the season, whenever the Giants took the field in Chicago, a group of fans seated near the visitors' bench would release 19 balloons into the air—one at a time. They chanted "one" in unison as the first balloon was sent up, continuing their countdown with each until all 19 were in flight. The next number was always shouted louder then the previous one. Needless to say, it was not designed to boost the Giants' morale. More often then not, they left town demoralized and defeated.

Johnny Evers poses at second base in this *c.* 1906 photograph taken at West Side Grounds.

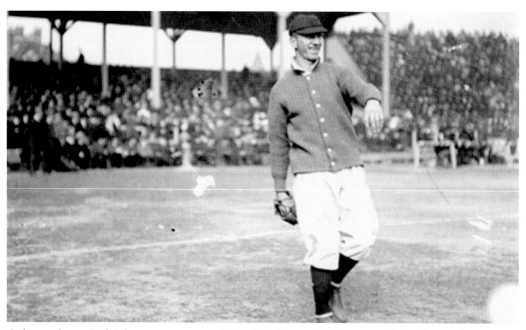

Cubs southpaw Jack Pfiester warms up at West Side Grounds. Pfiester made his first real impact in the majors with the 1906 Cubs, posting a 20-8 record for the pennant winners. His second-best season came in 1909 when he went 17-6. Thereafter recurrent arm problems led to an early retirement in 1911, but not before Pfiester had earned the nickname of "Giant Killer," winning 15 of 20 decisions against John McGraw's New York Giants.

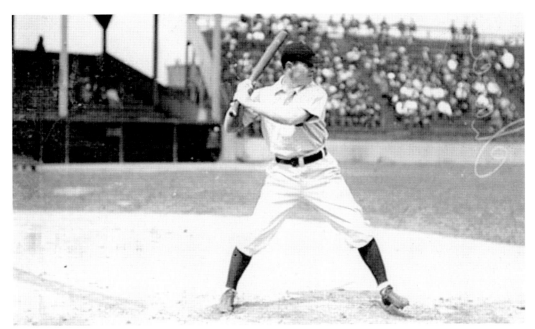

Even from a distance, Frank Chance appears to have a grim determination in his facial expression.

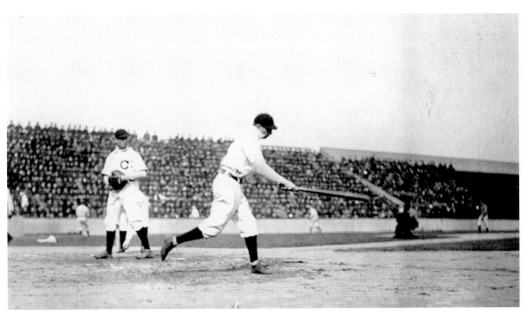

Pitcher Carl Lundgren swings a bat at West Side Grounds in 1906. That season, Lundgren served as an umpire for three straight games (August 31–September 2) when the scheduled arbitrator was sick with food poisoning. Reportedly, Lundgren gave the Cubs no preferential treatment. (Library of Congress.)

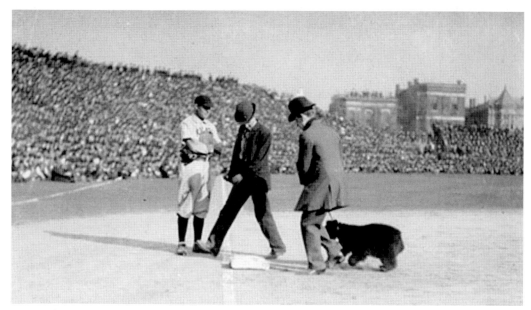

Two well-dressed fans walk a bear cub around the bases at West Side Grounds, presumably for good luck, in 1906. The player is unidentified. Perhaps this scene should be reenacted today at Wrigley Field to lift the "billy goat curse," which has hounded the Cubs since they won their last pennant in 1945. (Library of Congress.)

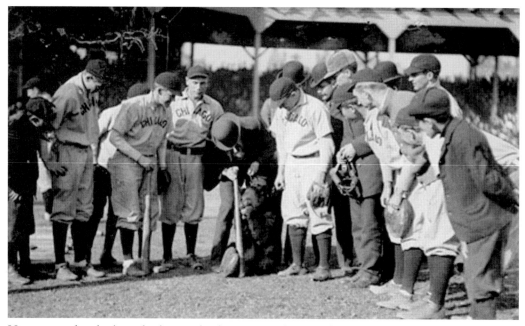

Here is another look at the bear cub, this time with several Cubs players and a few more fans getting in on the fun. By mid-June, with the Cubs beating up on the defending world champion New York Giants, the rest of the league was officially put on notice that Chicago was for real. (Library of Congress.)

CHICAGO CUBS

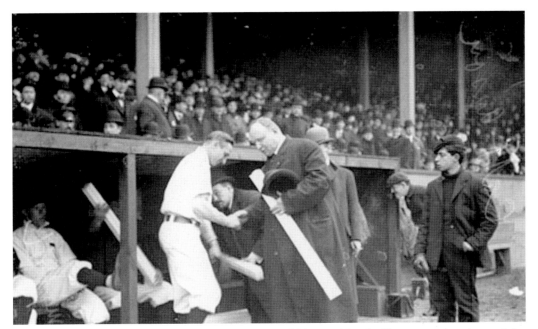

The legendary Adrian "Cap" Anson presents a gold bat to Frank Chance at the close of the record-setting 1906 season. The two missed being teammates by just one year; Anson last played in 1897, and Chance broke in the following season. (Library of Congress.)

A stately-looking Charles Murphy poses for a studio shot in 1906 or 1907. As owner-president of the Cubs from 1905 through 1913, the tight-fisted Murphy was not overly popular either with his players or the fans. The White Sox would face his highly favored Cubs in the 1906 World Series. (Library of Congress.)

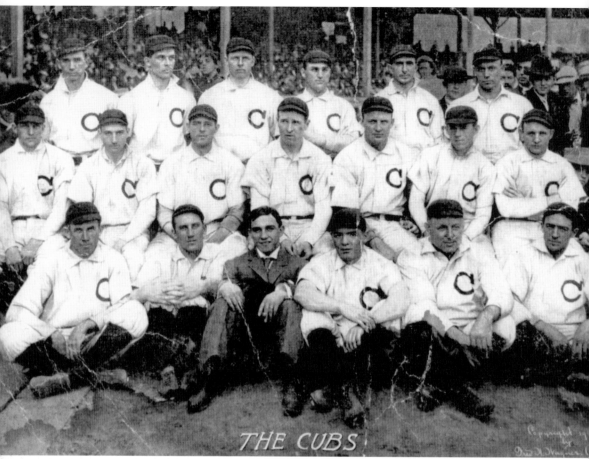

THE CUBS

Frequently called "Murphy's Spuds" in a humorous allusion to the new owner's Irish ancestry, the 1906 Cubs won a record 116 games against only 36 losses for a .763 winning percentage to finish 20 notches ahead of the runner-up Giants. Included were winning streaks of 14, 12, 11, and 10 games to terrorize the league. Between August 6 and September 16, they won an unbelievable 37 of 39 matches. Sitting with the team in street clothes is Kid Herman, a local prizefighter who apparently was a big Cubs fan. Virtually everyone predicted a quick knockout of the White Sox in the World Series.

CHICAGO CUBS

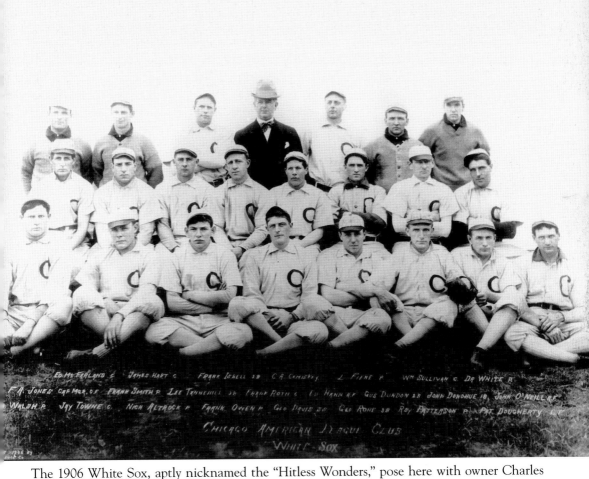

The 1906 White Sox, aptly nicknamed the "Hitless Wonders," pose here with owner Charles Comiskey in the center of the third row. Few had given them a chance against the mighty Cubs, who they would defeat in six games. John McCutcheon's cartoon in the *Chicago Tribune* summed it up succinctly. Captioned "Comiskey at Home," it depicted nine bear skins thrown on a living room floor or nailed to the wall, while a gentleman wearing white socks reclines in an easy chair, reading his newspaper.

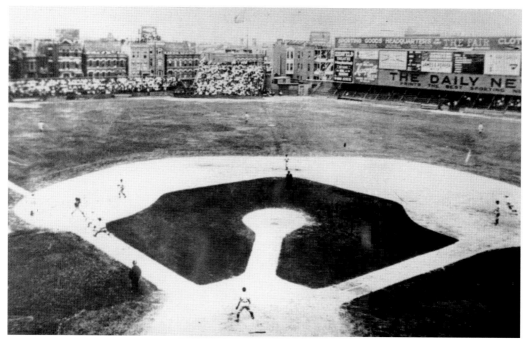

The Cubs are playing the White Sox in this scene from the 1906 World Series at West Side Grounds. This must have been Game 1, 3, or 5. But Game 2 at South Side Grounds was the high point for the Cubs. Ed Reulbach's one-hit victory that day was a feat not duplicated in World Series play until 1945, when another Cub, Claude Passeau, turned the trick against the Detroit Tigers.

Frank Isbell, second baseman for the White Sox, was their leading batsman with a .279 average. Interestingly, Isbell began his career with the Cubs in 1898. (OTBAC.)

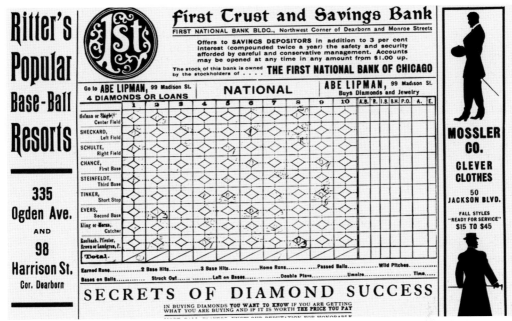

This score sheet from the 1906 World Series was courtesy of the *Chicago Evening Post*, which went out of business in 1932. The various advertisements from one century ago seem quaint today. The Cubs lineup is on top and the White Sox below; sadly for Cubs fans, this is not how the series ended in the standings.

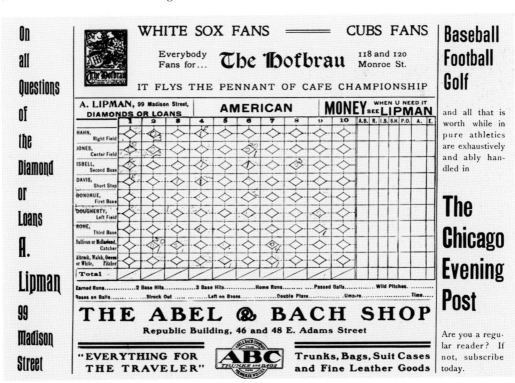

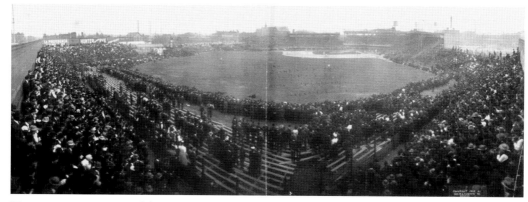

Here are some scenes of the 1906 crosstown World Series. Seen above left is Game 5 . It was played at the Cubs West Side Grounds on October 13. The White Sox took this game, 8-6, Ed Walsh the winning pitcher over Cubs hurler Jack Pfiester. Game 6, the deciding game of the series seen above right, was played at the White Sox home field, South Side Park, the next day.

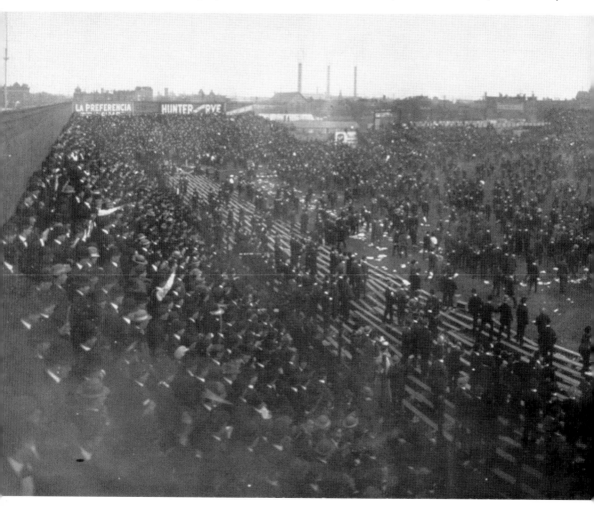

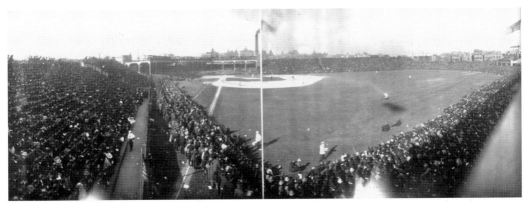

South Side Park (seen below) empties out after the final game. White Sox fans partied while Cubs rooters made themselves scarce. In those days, fans were allowed to exit via the playing area in nearly every ballpark. (Library of Congress.)

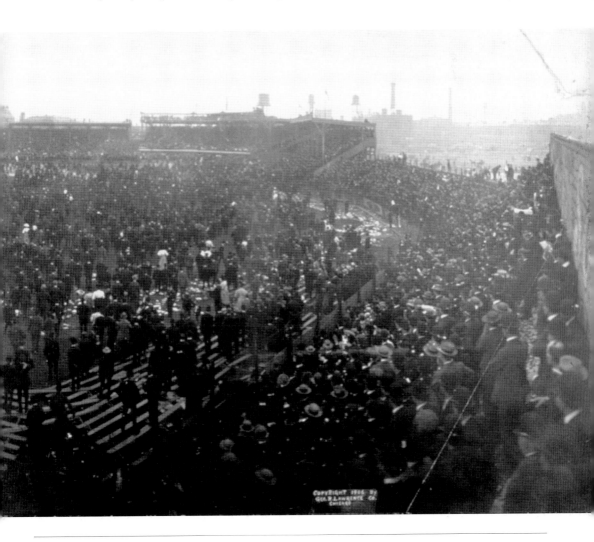

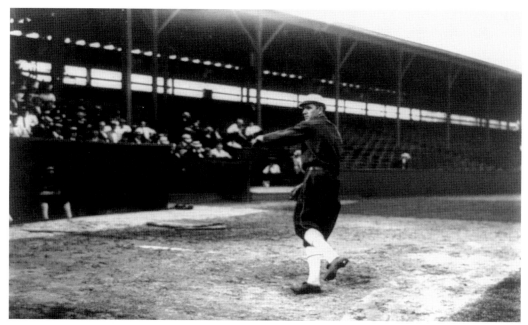

Pictured here is Guy "Doc" White, White Sox hurler who finished the Cubs off in Game 6. He also lost Game 2 and came in to relieve (not yet an official stat) Ed Walsh in Game 5.

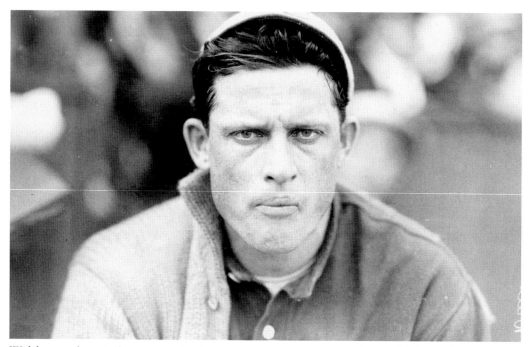

Walsh, seen here in later years, did his part too, winning Games 3 and 5. The Hitless Wonders needed the strong arms of White and Walsh as they lived up to form, batting .198 as a team against the Cubs. Not to be outdone, the Cubs, who had led the league in so many offensive categories during the season, hit .196 as a club in the series.

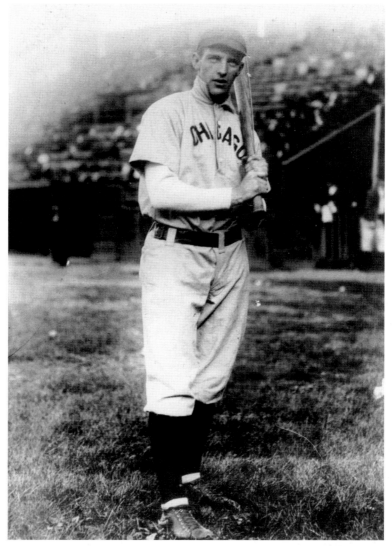

Cubs outfielder Frank Schulte, posing here in his road uniform in 1906 or 1907, was involved in the most controversial play of the World Series—George Davis's devastating first-inning double. Schulte contended that he would have caught it but "that a policeman in uniform came up and pushed him while he was waiting right in front of the crowd for the ball," as was reported in the *Spalding Baseball Guide* of 1907. Most of the newspapers carried this story, some of them substituting "tripped" for "pushed." However, an obscure paragraph in the *Chicago Tribune* blamed the misdeed on "mute, inglorious Milton," an eight-year-old boy. As it was with Babe Ruth's "called" home run against the Cubs in the 1932 World Series, the full truth regarding Davis's double will probably never be known. It led the Cubs to ruin regardless. Infuriated by the decision, Frank Chance insisted on a ruling of interference and that Davis be called out, but the umpires turned a deaf ear. To Cubs fans of today, this whole scene sounds eerily similar to an unfortunate occurrence of fan interference during the 2003 National League Championship. (Brace.)

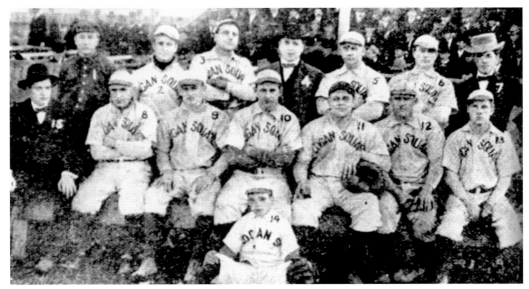

Pictured in this rare image is Jimmy Callahan's semiprofessional team from the Logan Square neighborhood on the city's northwest side. The Logan Squares defeated both the Cubs and the White Sox, with each team putting their best on the mound, in exhibition contests after the 1906 World Series to claim city bragging rights. Callahan, who had previously played for both the Cubs and the Sox, is seated in the center of the middle row. He returned to the White Sox in 1911.

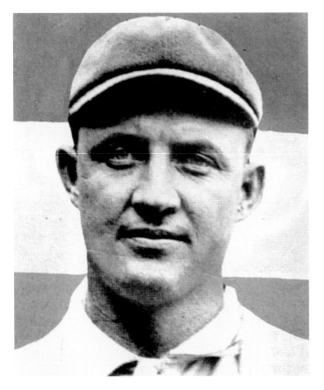

Cubs pitcher Orval Overall cracks a semi-smile in this close-up. Picked up in mid-season by Chicago, his 12 wins and 1.88 ERA with the club gave Cubs fans plenty to smile about. Overall combined with Carl Lundgren and Ed Reulbach to give the Cubs three pitchers who were college educated, a rarity in those days.

4

CHAMPIONS

1907–1908

Frank Chance, more bent than ever toward leading the Cubs to a World Series victory, was determined not to let the embarrassment of October 1906 happen again, as were his subordinates.

As had been the case the previous year, the 1907 pennant race was a one-team affair—namely, the Cubs. While they did not ring up as many wins as in 1906, their 107-45 record for a .704 percentage was still good enough for a 17-game margin over the runner-up Pittsburgh Pirates. The Cubs performed consistently all season as their lead was never seriously challenged.

It was smooth sailing as the Cubs took their second straight pennant and without a single .300 hitter on the squad. Chance was the leader of the pack at .293. Pitching was better than ever, though, as Chicago's pitching corps chalked up 30 shutouts with a collective ERA of 1.73, still the record low. The individual figures were equally breathtaking: Jack Pfiester, 1.15; Carl Lundgren, 1.17; Mordecai Brown, 1.39; Ed Reulbach, 1.69; and Orval Overall, 1.70. Jack Taylor, whose ERA had swollen to an unspeakable 3.29, was released in September. The top winners were Overall with 23 victories, Brown with 20, and Lundgren with 18.

With the White Sox having slipped to third place, the Cubs' opponents in the World Series were the Detroit Tigers, led by the colorful Hughie Jennings. On paper, the 1907 Tigers looked like a harder team to beat than the 1906 White Sox. Two months short of his 21st birthday, Ty Cobb won his first of 12 batting titles with a .350 mark. Outfield teammate Sam Crawford was second at .323, while Detroit's team batting average of .266 was best in the majors in that pitching-dominated era. While the Tigers' pitching was not as good as that of the White Sox, their staff of Wild Bill Donovan, Ed Killian, George Mullin, and Ed Siever were nothing to scoff at either. Not wishing to eat crow again, the sportswriters and oddsmakers this time viewed the Cubs with only cautious optimism. Their fears would soon be allayed.

The World Series opened at West Side Grounds on October 8, 1907. In the bottom of the ninth, the Tigers nursed a 3-2 lead with two out and Harry Steinfeldt on third. Pinch-hitter Del Howard struck out but Detroit catcher Charlie Schmidt committed a passed ball, allowing Steinfeldt to cross the plate with the tying run. The score remained knotted up at 3-3 until the game was called because of darkness after the 12th inning. Hoping for a comeback win, the packed house of 24,377 went home disappointed but not disheartened.

From that point on, the World Series was a cakewalk for the Cubs. On October 9, Jimmy Slagle drove in the go-ahead run with a fourth-inning single, then scored an insurance run

on Jimmy Sheckard's double as Jack Pfiester beat the Bengals, 3-1, for his only World Series triumph before another standing-room-only crowd of 21,901. The next day Johnny Evers led the charge with two doubles and a single, while Ed Reulbach had the Tigers eating out of his hand, scattering six hits in a 5-1 win. Both teams then boarded the train for Detroit, with Hughie Jennings hoping that his team would fare better on its home turf.

Such was not to be the case. At Bennett Park, on October 11, the Cubs slammed the door on the Tigers, 6-1. Pitcher Overall aided his own cause with a go-ahead two-run single in the fifth. The following afternoon, the Cubs celebrated Columbus Day by goose egging the Tigers, 2-0, behind Mordecai Brown to clinch the World Series. A meager assemblage of only 7,370 turned out at Bennett Park to witness the final nail being pounded into the coffin of their favorites. Harry Steinfeldt murdered the Tigers hurlers with a .471 series average.

The sweep of Detroit proved to the baseball world that despite the upset victory by the White Sox in 1906, the Cubs were the preeminent team of the diamond. Having tasted World Series victory, the Cubs were anxious to repeat. But unlike the previous two seasons, in which the Cubs ran away with the flag, the 1908 race would be a three-way battle to the finish between the Cubs, Giants, and Pirates. And the Chicago-New York enmity was reaching its zenith.

As the season wore on, Chicago, New York, and Pittsburgh continued to struggle for the lead, with the Giants clinging to the number one slot by a slim margin. The turning point came at New York's Polo Grounds on September 23. The Cubs had swept the Giants in a double-header the day before, reducing their lead to one and a half games. Obviously, the excitement and tension were mounting.

With Jack "the Giant Killer" Pfiester on the hill, the score was tied at one apiece when New York came to bat in the last of the ninth. With two out and two on—Moose McCormick at third and rookie Fred Merkle at first—Al Bridwell sent Pfiester's first offering to center field as McCormick crossed the plate in an apparent 2-1 Giants victory. But Merkle stopped running toward second base and headed for the clubhouse instead.

As fans swarmed onto the field thinking the game was over, Johnny Evers, in his shiniest hour, stood perched at second base screaming for the ball. Artie Hofman fired the ball in, but it went over Joe Tinker's head to where Giants pitcher Joe McGinnity was standing. McGinnity and Tinker began wrestling, with McGinnity heaving the ball into the crowd.

Floyd Kroh, a substitute Cubs pitcher, managed to retrieve the ball (or one just as good, anyway) and threw it to Evers, who promptly stepped on second base. Umpire Hank O'Day ruled Merkle out for failure to touch the bag, thereby nullifying the winning run. With pandemonium on the field and an angry mob ready to hang Evers and O'Day from lampposts, it was impossible to resume play, and the game was called as a 1-1 tie. A fuming John McGraw ranted like a raving maniac as the hated Cubs had to return to their hotel under police guard. League officials would later uphold O'Day's decision, ordering the game to be replayed if it were a factor in the championship.

Two weeks later the standings read, Cubs, 98-55; Pirates, 98-56; and Giants, 95-55. The regular season was over for the Cubs and the Pirates; the Giants, however, had three games to play with Boston. The Giants won all three, necessitating a replay of the September 23rd game. In the days that followed, Johnny Evers was harassed by intimidating telephone calls, while Mordecai Brown received death threats in the mail. The situation was tense as the replay date of October 8

approached. Nevertheless, the Cubs once again escaped the Polo Grounds with a victory and a mob of angry fans at their heels—this time with a pennant.

After the ordeal in New York, a relaxing train ride and a day off were just the tonic that the Cubs needed as they pulled into Detroit for a World Series rematch with the Tigers. Lacking the drama of the National League pennant race, the Cubs once again tamed the American League champions in five games, claiming back-to-back World Series titles.

Over the winter months, relations between Chance and Charles Murphy deteriorated further over contract negotiations in what would ultimately prove to be a bad omen. At one point Chance threatened to quit baseball, but changed his mind when a new contract was finally hammered out. The two-time championship team was thus preserved and poised to attempt yet one more run at the pennant.

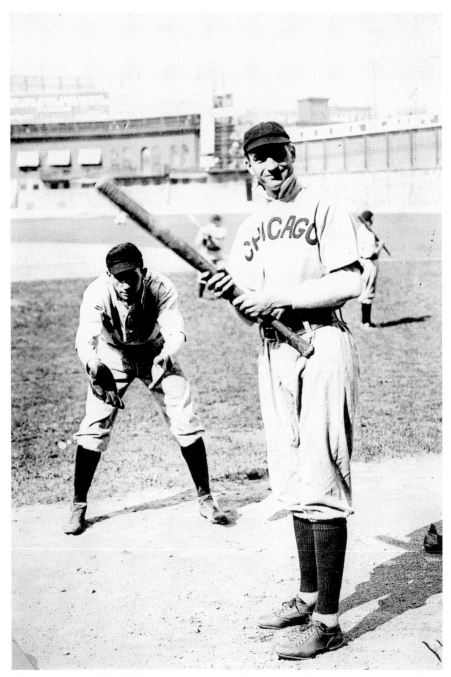

Cubs utility man Artie "Solly" Hofman mugs for the camera. He had joined the Cubs in 1904 as a jack-of-all-trades. With Frank Chance, Frank Schulte, and Joe Tinker in the hospital or on the bench for significant time periods during the 1907 campaign, Hofman filled in at all three positions and did a creditable job. As a "full-time part timer" (or "part-time full timer"), he played in 134 games, batting .268. In late August 1908, after four years as a super substitute, he became the Cubs' regular center fielder. (Library of Congress.)

CHICAGO CUBS

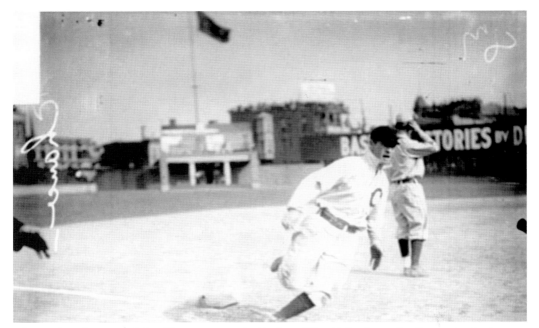

Chance hustles around third base against the Reds at West Side Grounds. Coming to be known as the "Peerless Leader," Chance was a stern disciplinarian, not averse to using his fists to send an unruly player a message. He was not a teetotaler, however, and had no objection to his players enjoying alcoholic beverages as long as they were in bed by midnight and in good shape for the next day's game. (Library of Congress.)

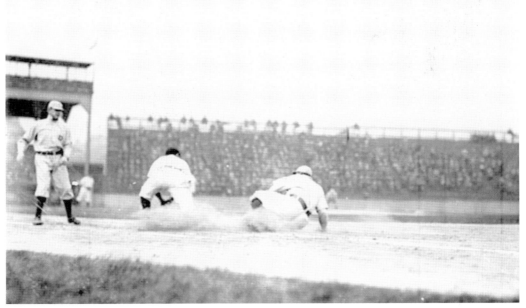

Pirates great John "Honus" Wagner (far right) slides back to first, manned by Chance at West Side Grounds in 1907.

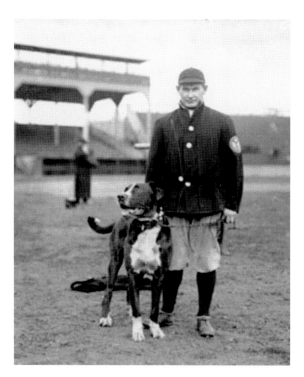

Third-string catcher Mike Kahoe is seen in 1907 at West Side Grounds with a large dog, presumably his pet. (Library of Congress.)

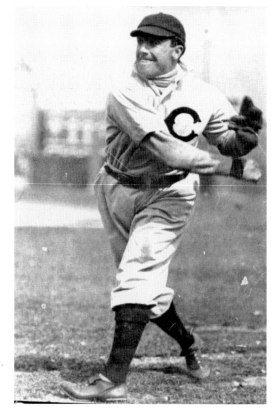

Shortstop Joe Tinker makes a throw in this 1907 action shot. The 1907 home jerseys displayed a wishbone "C" and the team of Tinker, Johnny Evers, and Frank Chance was universally called the Cubs by all the newspapers. That year, the name Cubs first appeared on the club's scorecards; previously only the word Chicago was used, as the team was often referred to in print as the "Chicagos."

Catcher Johnny Kling poses for photographers at West Side Grounds in 1907. Teammate and pitcher Ed Reulbach called Kling "one of the greatest catchers who ever wore a mask." And he did so with good reason, as Kling led the league in putouts six times, fielding four times, and assists twice, as well as topping the circuit once in double plays for good measure.

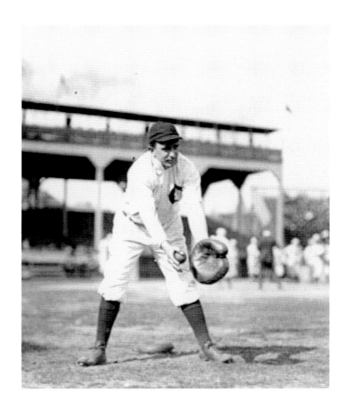

Kling takes a practice session at the home ballpark in 1907. On June 21 of that season, he threw out all four would-be Cardinals base stealers to help Mordecai Brown to a 2-0 win, his 10th straight.

An unidentified lady, obviously a Cubs fan, displays her team paraphernalia during the 1907 season. (Library of Congress.)

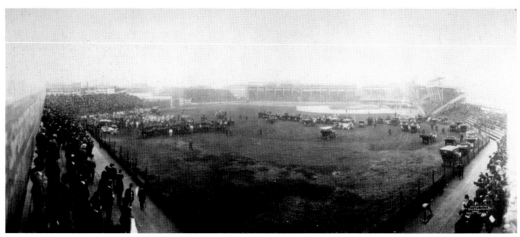

A pennant raising ceremony takes place at West Side Grounds to celebrate the 1907 National League champion Cubs.

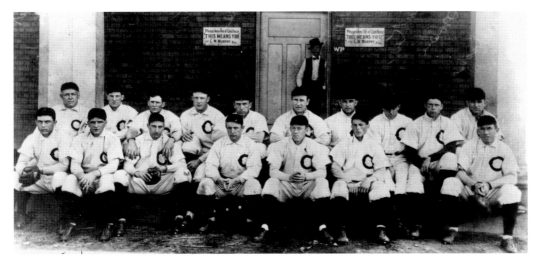

Above are the 1907 Cubs at West Side Grounds. Going 107-45 for the year, they finished 17 games ahead of the second-place Pirates. Pitching was at its zenith as Cubs hurlers threw 30 shutouts and had a staff ERA of 1.73, still the lowest in major-league annals. This time, their opponents were the Detroit Tigers, who the Cubs skinned in four straight, after the first game was called on account of darkness after 12 innings, a 3-3 tie. In the 1908 World Series, the Cubs outran the Tigers with 18 stolen basses in five games, including six by Jimmy Slagle (front row, fourth from right). Slagle's total would remain the World Series record until broken by Lou Brock of the Cardinals in 1967, and it took Brock two more games to exceed it.

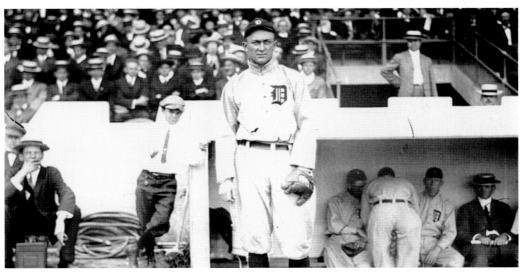

Revealing his intense profile for the camera is Tigers great and future hall of famer Ty Cobb, who faced Cubs pitching in a losing cause during the World Series of 1907. Cubs pitching had held the great Cobb to a measly .200 average while the speedy Georgian failed to steal a single base off Johnny Kling's powerful throwing arm. Years later, Cobb, not one to dish out compliments, would describe Mordecai "Three Finger" Brown as the most devastating pitcher he ever faced. (OTBAC.)

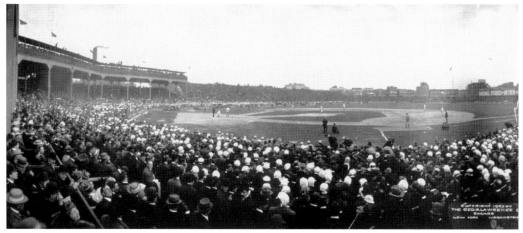

West Side Grounds is packed to the rafters for Game 2 of the World Series on October 9, 1907. The Cubs won the game, 3-1.

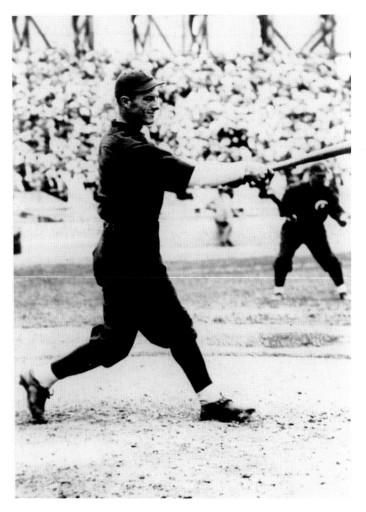

Henry "Heinie" Zimmerman joined the Cubs as a rookie in 1907 and was used as a utility infielder. A poor fielder but dangerous at the plate, Zimmerman's best years as a Cub were still ahead of him. (Brace.)

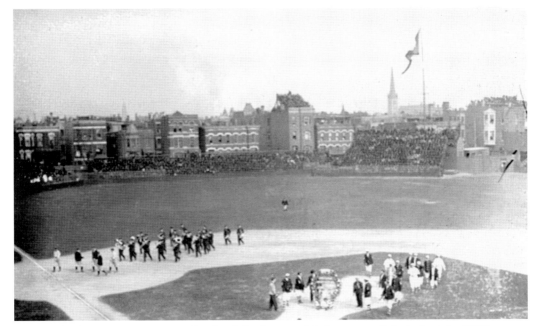

Here is the flag raising ceremony for the defending world champion Cubs before the 1908 season home opener at West Side Grounds.

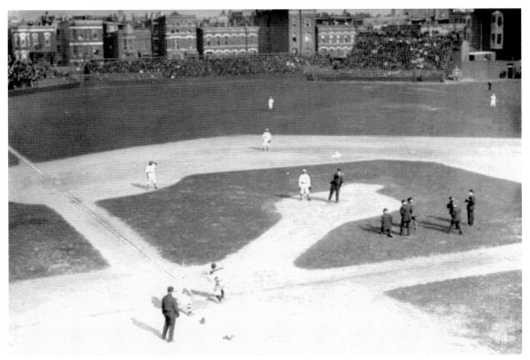

Following the pregame ceremonies, 19th-century legend Adrian "Cap" Anson throws out the first pitch of the 1908 campaign. To make the first home game complete, the Cubs beat the Reds, 7-3.

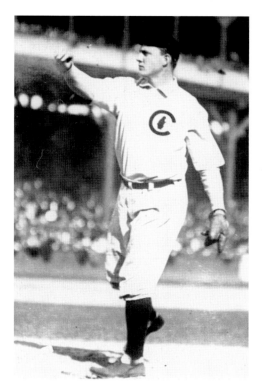

Orval Overall was traded to the Cubs from the Reds in July 1906. In the ensuing years he excelled on the mound, going 23-8 in 1907 and 20-11 in 1909 with a league-leading nine shutouts. In 1909, his 205 strikeouts, which also led the league, made him the last Cubs hurler to fan over 200 batters in one season until Fergie Jenkins whiffed 236 in 1967.

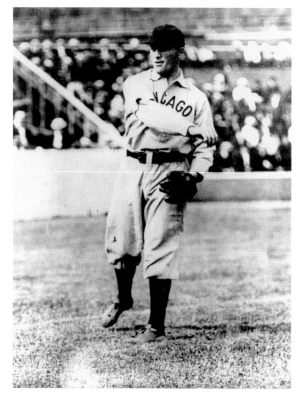

Here is a nice shot of shortstop Joe Tinker on the road in 1908. During the winter months, the Cubs and their followers basked in the sunshine of holding baseball's world title. As the 1908 campaign began, the team's home uniforms displayed a distinctive "Cub" emblem for the first time—a large "C" enclosing a bear cub carrying a baseball bat. The fact that the team had just won two straight pennants and a World Series solidified the name even further.

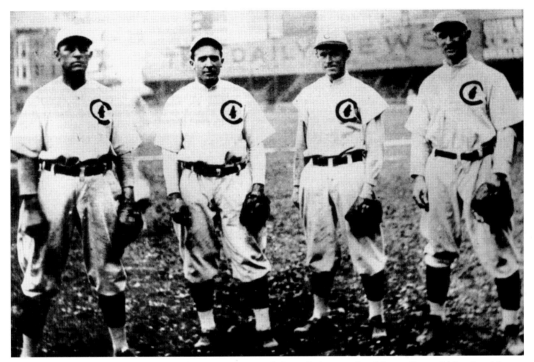

The world champion Cubs infield was made up of, from left to right, Harry Steinfeldt, third base; Joe Tinker, shortstop; Johnny Evers, second base; and Frank Chance, first base.

Mordecai Brown proudly displays the deformed pitching hand that helped lead the Cubs to four pennants and two World Series titles between 1906 and 1910. (OTBAC.)

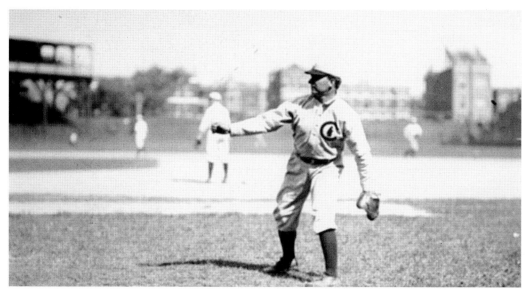

Cubs pitcher Charles "Chick" Fraser warms up at West Side Grounds in 1908. Fraser had been on the losing end of the 36-7 slaughtering of Louisville (then a major-league city) by Chicago on June 29, 1897, in the same ballpark. A well-traveled journeyman, he ended his career in Chicago as a spot starter and a reliever. Fraser did fairly well for the Cubs, going 8-5 in 1907 and 11-9 in 1908 before being released early the following year.

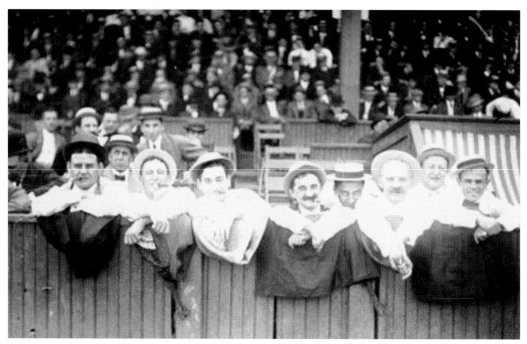

Pictured here are members of the Cubs Rooster Club at West Side Grounds in 1908. Akin to the bleacher bums of a later generation, these fellows do not appear to have been attending a temperance meeting.

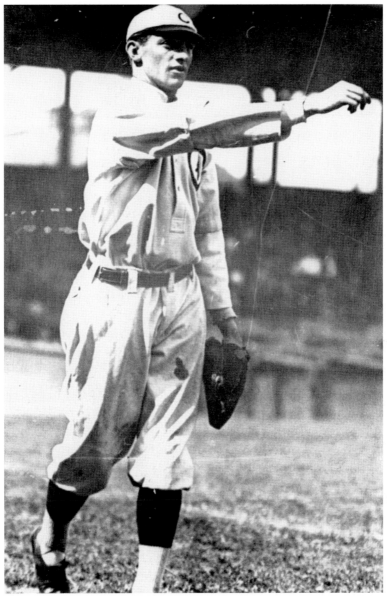

Cubs right fielder Frank "Wildfire" Schulte simulates a throw rather stiffly in this obviously posed photograph. Schulte joined the team in 1904 and became a regular in 1905. As the Cubs' number one home run hitter during the early dead ball era, Schulte paced the team with 7 in 1906, 2 in 1907, 4 in 1909, a league-leading 10 in 1910, and then an incredible 21 in 1911, which was also tops in the league. That 1911 season was the pinnacle of his career. While batting an even .300, Schulte added 30 doubles, 21 triples (a club record), and 23 stolen bases to his home runs, making him the first major-leaguer to amass more than 20 in all four categories in a single season. He remained in the Cubs starting lineup until traded to the Pirates, with declining productivity, in late 1916. Schulte was also renowned for visiting many a saloon along with popular sports columnist Ring Lardner during his Cubs days.

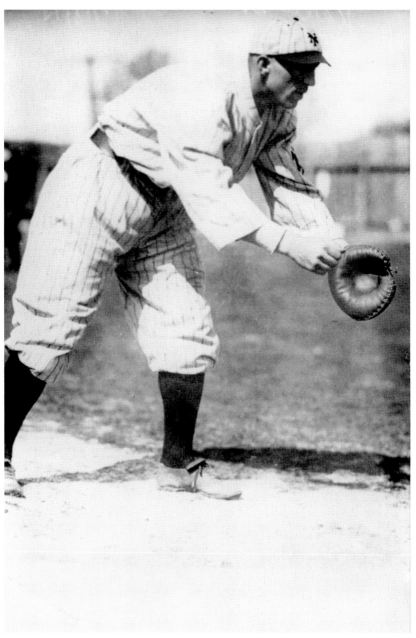

In this undated photograph appears New York Giants infielder Fred Merkle. It was his failure to touch second base as Moose McCormick crossed the plate with two out in the last of the ninth inning at the Polo Grounds on September 23, 1908, that turned an apparent 2-1 Giants victory over the Cubs to a 1-1 tie. Umpire Hank O'Day ruled Merkle out, and with fans swarming the field, it was impossible for play to continue. This base-running gaffe would be infamously dubbed "Merkle's Boner." It saddled Merkle with the demeaning epithet, "bonehead," for the rest of his career, despite being a fine ballplayer. Ironically, Merkle would later become the Cubs regular first baseman (1917–1920) while O'Day served as Cubs manager in 1914.

Hank O'Day's decision to call Merkle out in that historic game in 1908 nullified what was to be the winning run, allowing the Cubs a chance to win the replay and clinch the pennant two weeks later.

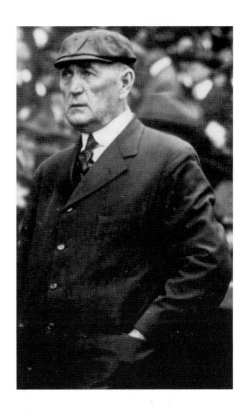

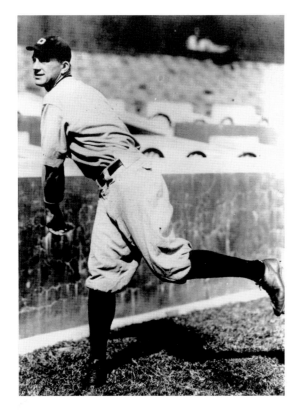

Pitcher Harry Coveleski, seen here as a Tiger around 1915, was a freshman for the Phillies in 1908. Coveleski aided the Cubs that season by beating the Giants three times during the stretch—on September 29, October 1, and October 3. Had the Giants taken just one of those games, they would have won the pennant. (Brace.)

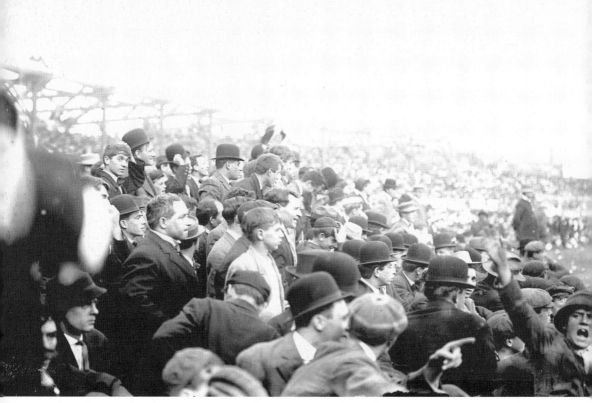

Seen here at that famous one-game playoff, a frenzied crowd of 35,000 Giants rooters showed up at the Polo Grounds on October 8, 1908, to see the same pitching match-up as on September 23—Christy Mathewson vs. Jack Pfiester. The interest was so high that fans broke down the ticket gates and part of the outfield fence. Hundreds of spectators climbed onto the grandstand roof, and others watched from telegraph poles or the bluffs overlooking the park. With this raucous backdrop, the Cubs beat the Giants, 4-2, a game that was won by Mordecai Brown, who was called in from the bullpen to rescue a struggling Pfiester during the first inning. In the final inning, Chance raced to the mound and told Brown to get it over quickly so they could "run for our lives." Brown followed orders, retiring the Giants on three pitches. With an infuriated mob at their heels, the Cubs dashed to their clubhouse in center field. Chance, Tinker, Scheckard, and Del Howard were roughed up while Pfiester sustained a knife wound on his shoulder. Police formed a cordon around the clubhouse, drawing their revolvers to hold back the unruly crowd. The Cubs rode back to their hotel in a paddy wagon with cops on the running boards. After darkness fell, they left by sneaking out a rear entrance and down an alley to the outbound train, again under police protection.

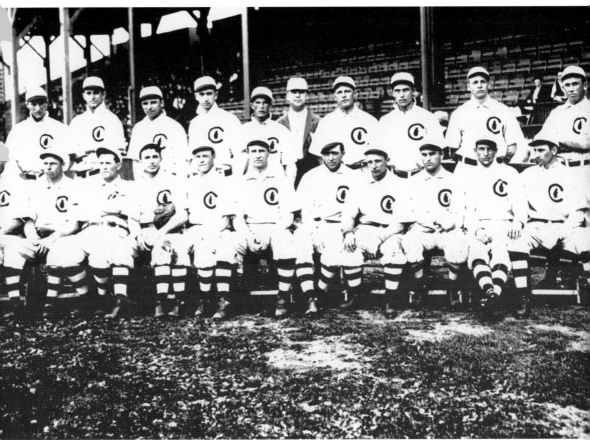

Here are the 1908 Cubs, the last Cubs team to win a World Series. While the Cubs and Giants battled for the pennant, their two top pitchers—Brown (first row, second from left) and Mathewson—had developed a keen rivalry of their own, resulting in many classic pitchers' duels. One such battle took place at West Side Grounds on July 17, 1908. The Cubs' three-fingered genius shut out the Giants, 1-0, on six safeties while Mathewson, who allowed only seven hits himself, made but one mistake. That came in fifth inning when he served a soft pitch to his nemesis, Joe Tinker (first row, fifth from right). The Cubs shortstop walloped it out to center field for an inside-the-park home run, beating Cy Seymour's throw to the plate. For the baseball crown, they made the Tigers roll over and play dead for the second year in a row.

CHAMPIONS 69

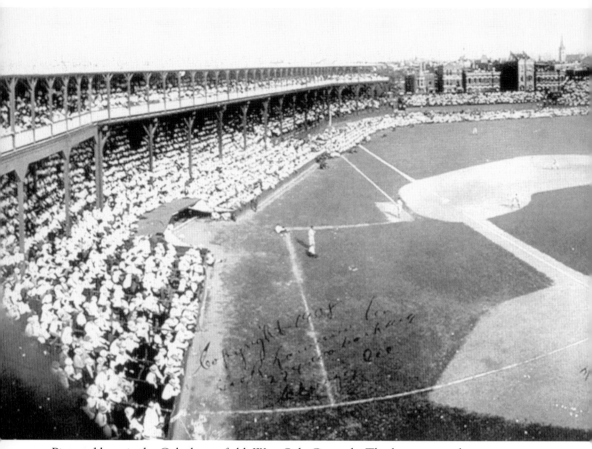

Pictured here is the Cubs home field, West Side Grounds. The largest crowd to ever see a game at this ballpark came on Sunday, October 4, 1908, as the pennant race reached its crescendo, and 30,247 fans watched the Cubs defeat the Pirates, 5-2, to clinch at least a tie for second place, necessitating a one-game playoff with the Giants. Winning that playoff, the American League champion Detroit Tigers again awaited the Cubs for the World Series. In the first game, on October 10, 1908, the Tigers nursed a 6-5 lead as the ninth inning began. The Cubs then pounded out six hits in a row for a five-run rally to emerge victorious, 10-6. Orval Overall did a masterful job in taming the Tigers in Game 2, holding them to four hits as the Cubs exploded for six runs in the bottom of the eighth inning to win, 6-1. Joe Tinker drove in the first two with a

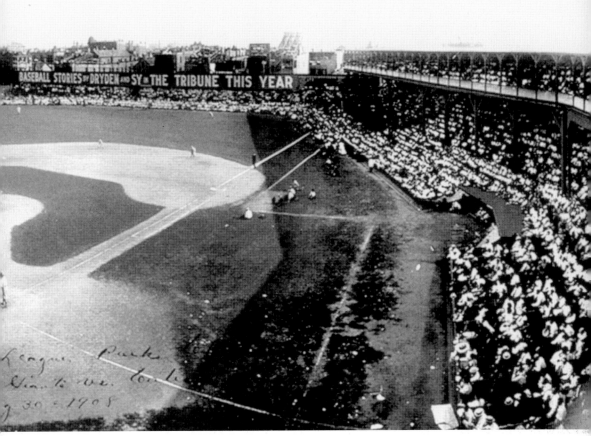

home run, the first by a Cub in World Series competition. On October 12, the Tigers overcame a 3-1 deficit with a five-run sixth off Jack Pfiester. Ty Cobb spearheaded the attack with a four-hit, two-RBI game as Detroit ace George Mullin held on to win, 8-3. The series returned to Detroit the next day as Mordecai Brown laced a complete game, 3-0 shutout, limiting the Tigers to four hits. And on October 14, the 1908 World Series came to a close with Overall making the Tigers look like dead cats, fanning 10 and giving up three hits in a 2-0 triumph. Before an assemblage of a mere 6,210 dispirited Tiger fans, the Cubs became the first team to win consecutive world titles. Frank Chance led the Cubs with a .421 average, followed by Johnny Evers at .350. Cobb solved Cubs pitching by hitting .368, but his teammates were unable to follow in his footsteps.

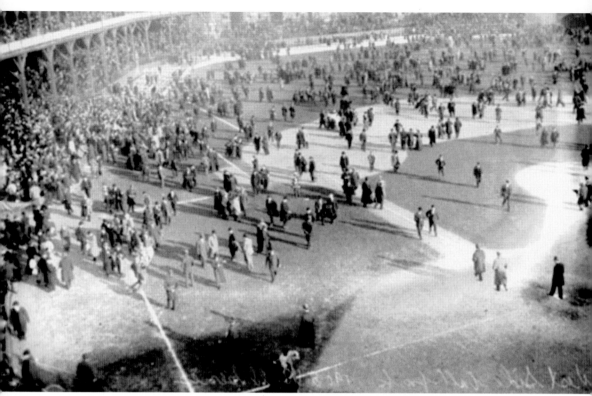

Cubs fans exit West Side Grounds via the field in either Game 2 or Game 3 of the 1908 World Series. A record crowd for Game 2 had been anticipated at the ballpark, but a less-than-capacity 17,760 paid their way in. The reason had nothing to do with the weather. With dollar signs in his eyes, Cubs owner Charles Murphy had jacked ticket prices up to five times their regular season level. In previous years, World Series admissions had gone for only twice the normal rate. Attendance for Game 3 slipped to 14,543 as Murphy's avarice backfired on him in a big way.

5

ONE LAST PENNANT

1909–1910

With Johnny Kling on leave of absence, the Cubs' catching in 1909 was handled by backup receiver Pat Moran and Dublin-born Jimmy Archer. While Archer later developed into a great catcher, he was not Kling's equal his first year and the defending world champions fell into second place. Upper management blamed Kling's "desertion" for the Cubs' failure to repeat, and never fully forgave him. The reality was not that simple. Although losing Kling did not help, it was not the only reason. Frank Chance's headaches were becoming more frequent and more severe, limiting his play to 93 games. High-strung Johnny Evers was given some time off to cope with his nerve problems. But the main cause was that the Pirates simply outdid them, winning 110 games to the Cubs' 104, which normally would have been enough.

Cubs fans had no reason to complain about how the team was playing. Pitching was still awesome as the staff ERA of 1.75 led the league, while their 32 shutouts tied the record set by the 1906 White Sox. The slumping Carl Lundgren was released early in the season, but the other "big four" of Brown, Overall, Pfiester, and Reulbach easily handled the load, with Brown winning 27 games and Reulbach enjoying a 14-game winning streak. Overall won 20 games and led the league in shutouts with nine and strikeouts with 205. He would be the last Cub to fan 200 batters in a season until Fergie Jenkins in 1967. In his first full season in a regular position, Artie Hofman batted .285 with 150 hits, both club highs. Still, after three straight pennants and two world championships, playing second fiddle was not much fun. The Cubs did regain local bragging rights by trouncing the White Sox, four games to one, in the City Series. But a City Series was not a World Series, as much as Cubs fans wished it was.

Defeated in his attempt to retain the pool championship, Johnny Kling received a hearty welcome when he rejoined the Cubs at the start of the 1910 campaign. His best years were now behind him, and he shared catching duties with the improving Jimmy Archer, who also filled in at first base when Chance was ailing.

The Cubs started off slowly but caught fire with an 11-game winning streak in late May and had a commanding lead by early July. On July 18, 1910, an eight-line poem by Franklin P. Adams appeared in the *New York Evening Mail*, entitled "Baseball's Sad Lexicon":

> These are the saddest of possible words:
> Tinker to Evers to Chance."
> Trio of bear cubs, and fleeter than birds,
> Tinker and Evers and Chance.

Ruthlessly pricking our gonfalon bubble,
Making a Giant hit into a double-
Words that are heavy with nothing but trouble:
"Tinker to Evers to Chance.

The poem caught on quickly, immortalizing the three and eventually creating a myth that they were the most prolific double play combination that ever played. Actually, from 1906 through 1909, all three participated together in only 54 double plays. Of this total, 29 went from Tinker to Evers to Chance while the other 25 went from Evers to Tinker to Chance. During the years in which they played as a unit on a more or less regular basis (1903–1910), the Cubs never led the league in double plays. With their pitching, they did not have to because so few enemy batters reached first base to begin with.

Mythology aside, the Cubs continued to play red hot ball. And it looked as if they had put their hitting shoes back on as well. Their league-leading 34 home runs were the most by a Cubs team since 1897, while the crew's .268 batting average was the team's highest in seven years. Hofman hit for a solid .325 with 86 RBI while Frank Schulte, who batted .301, topped the circuit in homers with 10. Tinker hit .288 and kept on terrorizing Christy Mathewson with 10 hits in 18 at-bats for a .556 average. Utility infielder Henry "Heinie" Zimmerman began to play on a semiregular basis, growing more proficient at the plate each day.

Pitching-wise, Mordecai Brown won 25 games, but it was rookie Len "King" Cole who stole the show with a 20-4 record for a league-leading .833 percentage and a 1.80 ERA. Included in his victories was a 4-0 no-hitter over the Cardinals at St. Louis on July 31 that had to be called after seven innings because both teams had to catch a train. The emergence of Cole could not have come at a more opportune time as Jack Pfiester, having arm problems, would soon be out of baseball.

The Cubs clinched the pennant on October 2 with an 8-4 victory against the Reds at Cincinnati, highlighted by a third-inning triple play, left fielder Jimmy Sheckard to catcher Kling to first baseman Archer. This was the only pennant clincher in Cubs history that included a triple play. On the negative side, Evers had broken his leg sliding into base the day before, putting him out of commission for the World Series. When the season ended on October 15, the Cubs' record stood at 104-50 for a 13-game edge over the second-place Giants.

This time the Cubs' foes in the World Series were the Philadelphia Athletics of Connie Mack, one of the smartest tacticians in baseball. Under his guidance, the Athletics had posted a 102-48 record, 14.5 games in front. Their infield of Harry Davis at first, Eddie Collins at second, Jack Barry at short, and Frank Baker at third rivaled (or bettered) that of the Cubs. Collins batted .322, stole 81 bases to lead the league, and led the junior circuit in every defensive category. Ace pitcher Jack "Colby Jack" Coombs (nicknamed after the college, not the cheese) went 31-9, while Charles "Chief" Bender was 23-5. The staff ERA was 1.79, lowest in American League history. Obviously they were not going to be a bunch of pushovers.

The Cubs went into the World Series as slight favorites but did not come out that way as the younger, speedier Athletics made mincemeat out of them in five games. The World Series opened on October 17 at Philadelphia's Shibe Park, where Bender handcuffed the Cubs on three hits, 4-1. The next day Coombs won an easy 9-3 victory, thanks to a six-run seventh inning.

CHICAGO CUBS

On October 20, the World Series moved to Chicago as Coombs and his cohorts again mugged the Cubs, 12-5, aided by five Cubs errors. The following day it rained in Chicago to give the Cubs a temporary reprieve. The Cubs' lone victory came on October 22 when Sheckard singled home Chance in the bottom of the 10th inning to edge of the Athletics 4-3, with Brown getting the win in relief. The Athletics wrapped it up the day after with a 7-2 mauling, as Coombs earned his third complete game victory.

In winning three games in the World Series, Coombs performed a feat matched by only a handful of others. It was also the first sign that Chance's machine was beginning to gather rust.

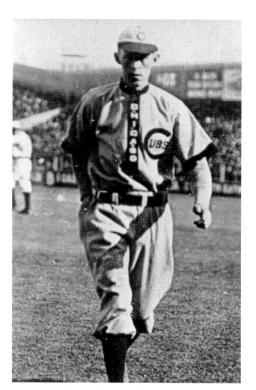

A sullen-looking Johnny Evers stalks off the field in 1909, the only year in which the Cubs road jerseys featured "Chicago" arranged vertically on the button panel. As his facial expression indicates, Evers was not called the "Crab" for nothing.

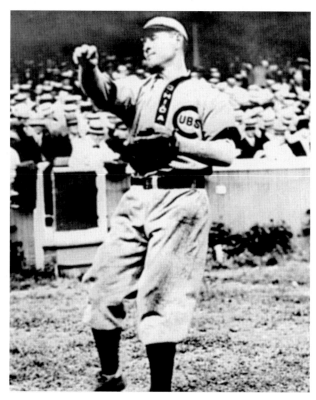

Frank Chance's migraine headaches were getting worse in 1909, limiting his action to 93 games. By 1911, Chance's appearances as a player were getting rare.

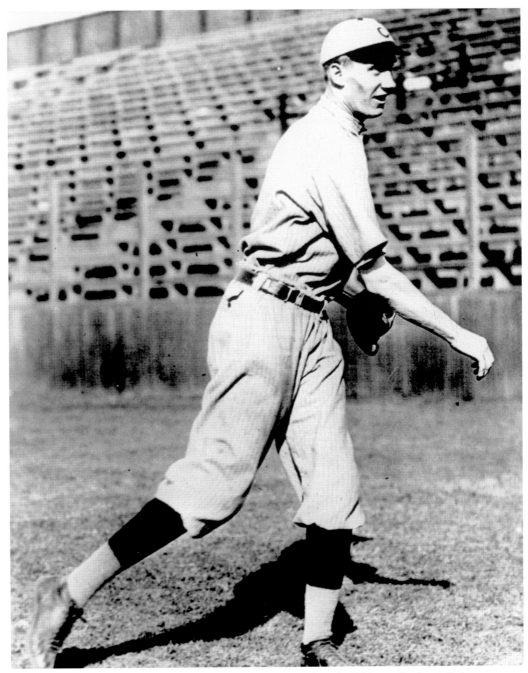

Len "King" Cole was brought up by the Cubs on October 6, 1909, pitched a 3-0 shutout over the Cardinals, and was signed to a contract. The following year the rookie wonder helped pitch the Cubs to their fourth pennant in five years. Cole posted a phenomenal 20-4 record and did almost as well in 1911 at 18-7. His productivity rapidly declined along with his health, and after stints with the Pirates and Yankees—pitching with his heart and his brain—Cole succumbed to cancer in January 1916, just three months shy of his 30th birthday. (Brace.)

With his catcher's mitt in hand, Jimmy Archer stands at West Side Grounds in 1909, his first year with the Cubs. That season he split duties with Pat Moran on a more or less even basis. (OTBAC.)

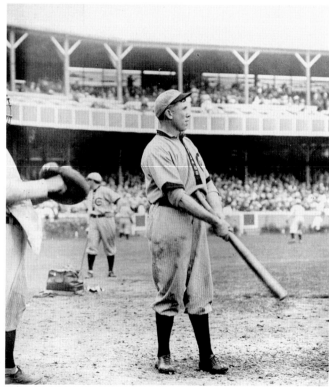

Seen here is the Cubs backup catcher Pat Moran, striding up to the plate on the road in 1909.

CHICAGO CUBS

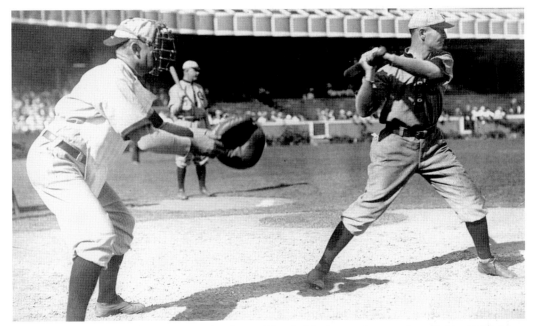

With Moran on deck, here is a terrific shot of Frank Chance at bat on the road in 1909. Now in his 12th season with the Cubs, Chance's productivity began its slow decline as he only saw action in 93 games that season. A career of free rides to first base, courtesy of the beanball, was taking its toll on Chance.

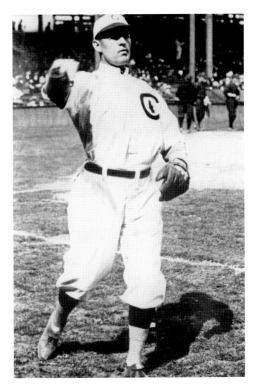

Cubs third baseman Harry Steinfeldt takes infield practice at West Side Grounds in 1909.

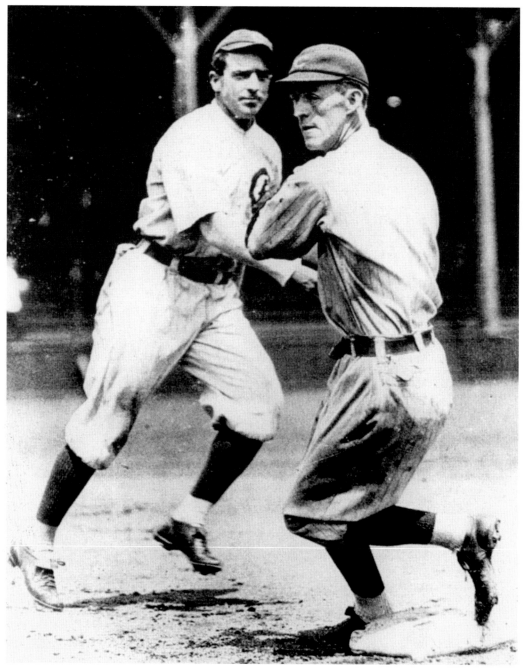

Joe Tinker and Johnny Evers execute a double play on the home grounds. On September 14, 1905, at an exhibition game in Washington, Indiana, Tinker and Evers had gotten into a fistfight over Evers taking a horse-drawn cab to the park by himself, leaving Tinker and several others behind at the hotel. Although Tinker and Evers did not speak to each other for some time, the legend that they remained enemies for over 30 years is just that—a legend. They were friends again by the time they turned this double play in 1909.

CHICAGO CUBS

Nation's Chief and Mordecai Brown Meet.

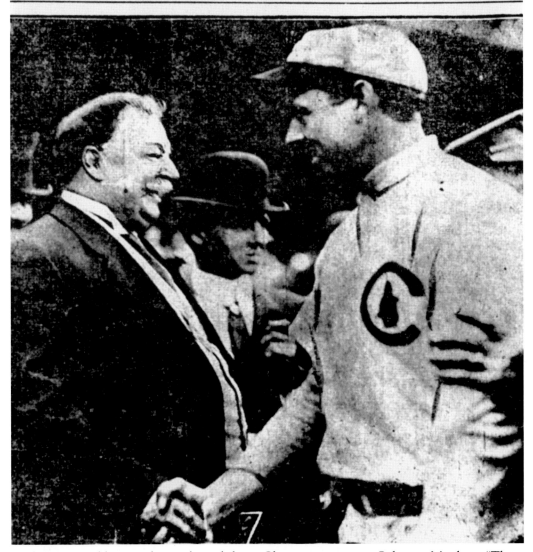

In this grainy old image from a long defunct Chicago newspaper, Cubs ace Mordecai "Three Finger" Brown shakes hands with Pres. William H. Taft at West Side Grounds on September 16, 1909. The game that long-ago afternoon was a classic pitcher's duel in which Christy Mathewson of the Giants edged Brown and the Cubs, 2-1, before a throng of 27,000. This was the only time a chief executive attended a Cubs home game while in office until September 30, 1988, when Ronald Reagan helped out in the broadcast booth at Wrigley Field. An ardent and knowledgeable fan himself, President Taft inaugurated the tradition of the president throwing out the first ball on opening day in Washington, D.C., in 1910. His half-brother, Charles P. Taft, later became part owner of the Cubs.

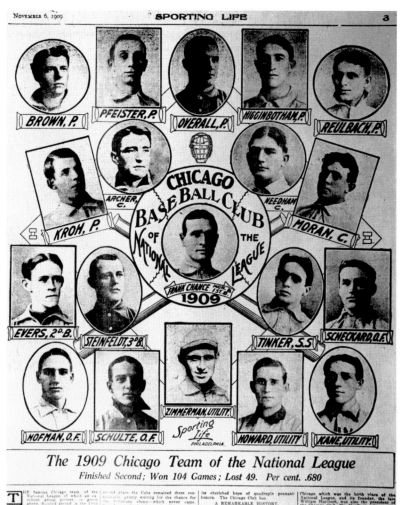

BROWN, P. — PFEISTER, P. — OVERALL, P. — HIGGINBOTHAM, P. — REULBACH, P.

ARCHER, C. — NEEDHAM, C.

KROH, P. — MORAN, C.

CHICAGO BASE BALL CLUB OF THE NATIONAL LEAGUE

FRANK CHANCE, MGR. 1ST B. 1909

EVERS, 2D B. — STEINFELDT, 3D B. — TINKER, S.S. — SCHECKARD, O.F.

HOFMAN, O.F. — SCHULTE, O.F. — ZIMMERMAN, UTILITY — HOWARD, UTILITY — KANE, UTILITY

Sporting Life PHILADELPHIA

The 1909 Chicago Team of the National League
Finished Second; Won 104 Games; Lost 49. Per cent. .680

The 1909 Cubs won 104 games, five more than the previous year. Since the Pirates won 110 games, the Cubs had to settle for being one of the best second-place teams in major-league history. The pitching staff's 32 shutouts tied the record set by the 1906 White Sox.

It is the Cubs vs. the White Sox again, this time in the City Series on October 9, 1909, at South Side Grounds. The Cubs won the postseason exhibition series, four games to one.

Winding up in this *c.* 1910 photograph is the New York Giants Christy Mathewson, who frequently squared off against the Cubs' Three Finger Brown during the halcyon days of Tinker to Evers to Chance. It was the Cubs and Giants again battling for the pennant in 1910. Despite another stellar outing by Mathewson, posting a 27-9 ledger with a 1.89 ERA (third best in the league behind Chicago's Len "King" Cole and Brown), the 91-63 Giants settled for second place, a full 13 games behind the resurgent Cubs.

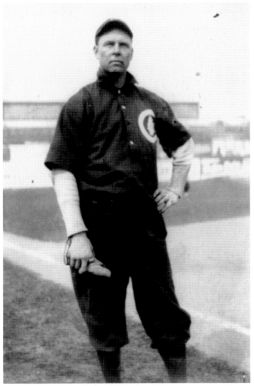

Brown's 25 wins and 1.86 ERA helped the Cubs to a 104-50 record and their fourth National League pennant in five years in 1910.

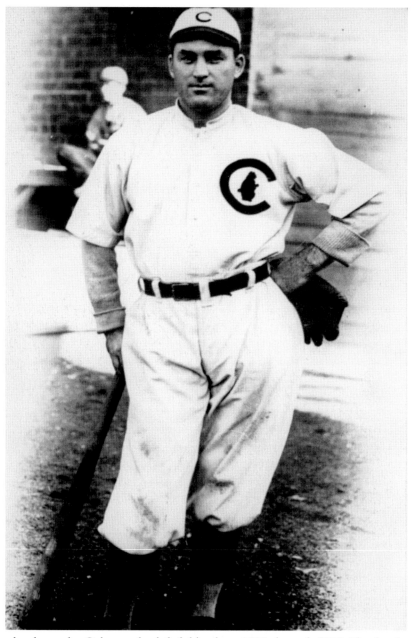

Jimmy Sheckard was the Cubs regular left fielder from 1906 through 1912. Sheckard enjoyed his best playing days with the Brooklyn Superbas, often leading or near the top of the league in batting average, RBI, and stolen bases. Although his hitting declined after coming to the Cubs, Sheckard was still an asset to the team because of his base-running skills and solid fielding. As a Cub, he led the league with 121 runs scored, 147 walks (still a Cub record), 32 assists, and 12 double plays as an outfielder in 1911. Just for good measure, he also topped the club in stolen bases with 32. Sheckard retired after the 1913 season and returned to the Cubs as a coach in 1917.

Cubs shortstop Joe Tinker fires the ball somewhere on the road in 1910. On June 28 of that year he became the first (and so far, the only) Cubs player to steal home plate twice in one game, during an 11-1 romp over the Reds. Generally a light hitter, in 1906 Tinker began hitting Christy Mathewson as if he owned him. In previous seasons, he had been Mathewson's number one patsy, but from 1906 to the end of his career, Tinker belted Mathewson at a .379 clip.

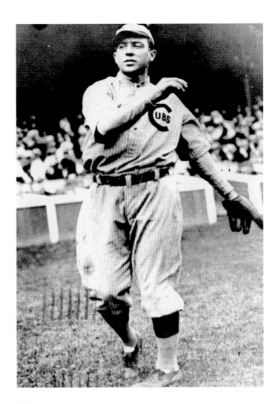

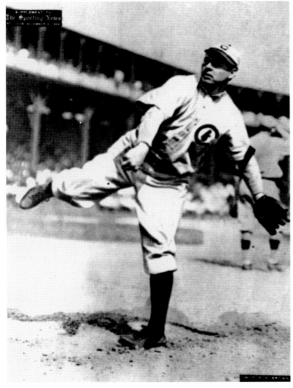

Mordecai Brown warms up at West Side Grounds in 1910.

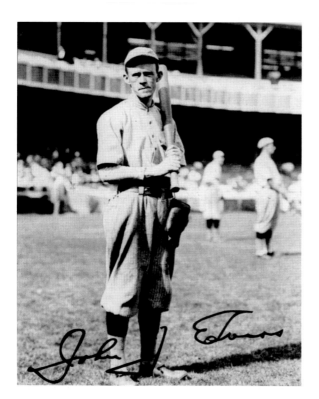

Here is an autographed shot of Johnny Evers from around 1910.

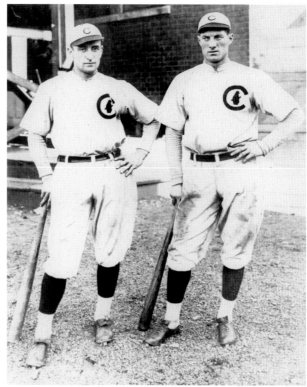

Jimmy Archer (left) and Heinie Zimmerman pose at the home ballpark in 1910. Still utility players at that point, both would become regulars the year after.

Ed Reulbach, seen here in his 1910 road uniform, joined the Cubs in 1905, and starting in 1906, he had the best winning percentage in the National League for three consecutive years as he went 19-4 (.826), 17-4 (.810), and 24-7 (.774). On September 26, 1908, he became the only pitcher in major-league history to twirl a shutout doubleheader, beating the Trolley Dodgers at Brooklyn 5-0 in the morning game and 3-0 in the afternoon game. He went 12-8 with 23 starts in 1910.

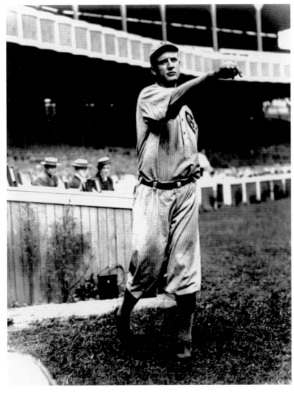

Orval Overall posted a 12-6 ledger for the pennant winners. It would be his last winning season, Overall retired after the 1910 season but returned briefly in 1913, going 4-4.

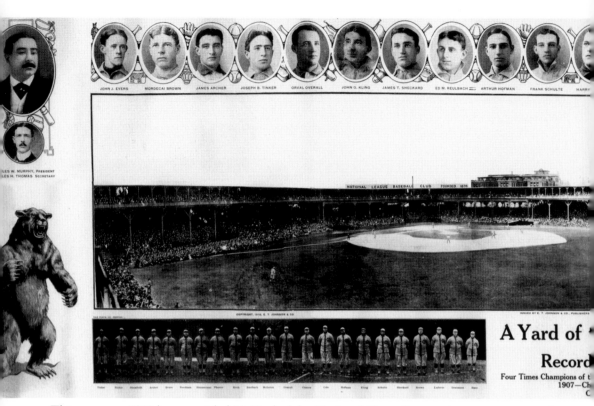

This gorgeous 1910 banner, titled "A Yard of the National Game," was quite a memento to the

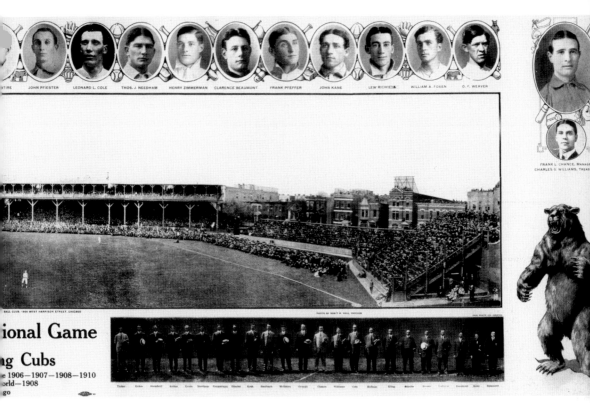

JOHN PFIESTER — LEONARD L. COLE — THOS. J. NEEDHAM — HENRY ZIMMERMAN — CLARENCE BEAUMONT — FRANK PFEFFER — JOHN KANE — LEW RICHIEDE — WILLIAM A. FOXEN — O. F. WEAVER

FRANK L. CHANCE, Manager
CHARLES G. WILLIAMS, Treas.

ional Game

g Cubs

e 1906—1907—1908—1910
orld—1908
go

team that had won four pennants in five years.

Cubs catcher Johnny Kling demonstrates his throwing technique in this posed shot for the *Sporting News* in 1910, his last full year in Chicago.

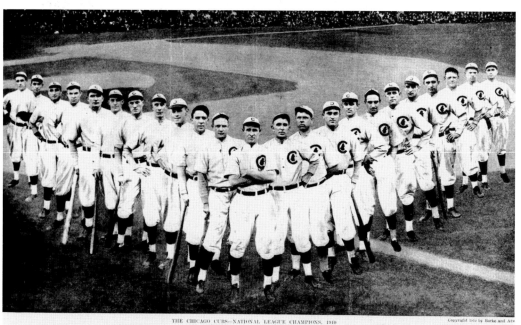

THE CHICAGO CUBS—NATIONAL LEAGUE CHAMPIONS, 1910
Reading from left to right—Kane, Richie, Pfeffer, McIntyre, Needham, Schulte, Zimmerman, Cole, Evers, Tinker, Overall, Chance (manager, in center), Kling, Brown, Sheckard, Reulbach, Hofman, Steinfeldt, Archer, Pfiester, Beaumont, Weaver, Foxen

Winners of 104 games, the 1910 Cubs stand in a "V" formation for victory in this one-of-a-kind image, superimposed upon the diamond background.

The bear logo here might seem more familiar to fans of the city's football team today, although it was used in 1910 to embody the ferociousness of Frank Chance's pennant-winning Cubs.

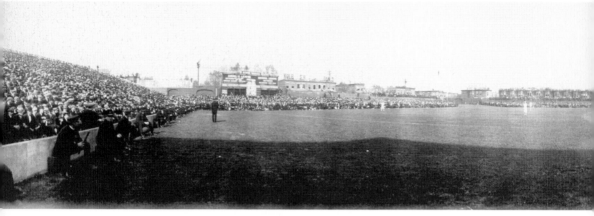

Here's a rare panoramic view of Philadelphia's Shibe Park in 1910. The City of Brotherly Love would host the Cubs that year for Games 1 and 2 of the World Series, with the Athletics winning

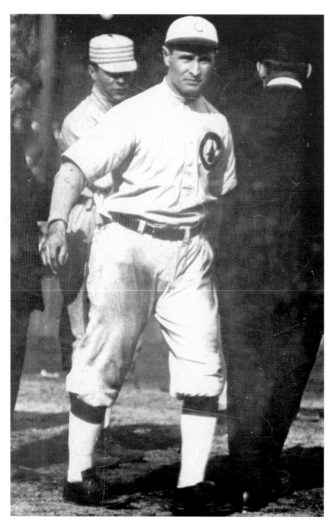

Frank Chance disputes an umpiring call during the 1910 World Series.

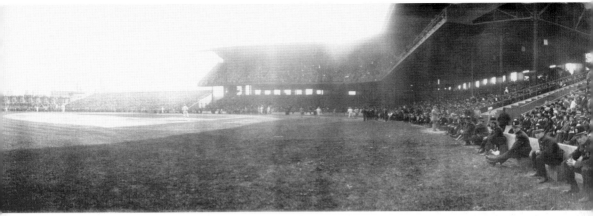

both en route to a four-games-to-one upset over the favored National League champions.

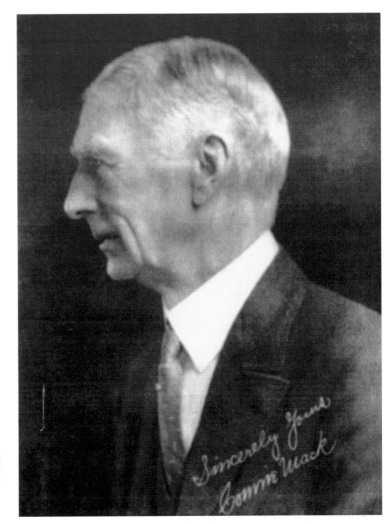

Pictured here about 25 years later is Connie Mack, whose Philadelphia Athletics defeated the Cubs in the 1910 World Series. In a half-century as their manager, Mack led some of the greatest and worst teams in baseball annals. (OTBAC.)

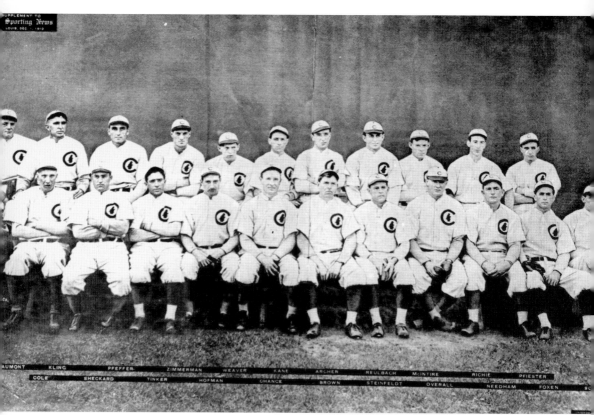

AUMONT KLING PFEFFER ZIMMERMAN WEAVER KANE ARCHER REULBACH McINTIRE RICHIE PFIESTER

COLE SHECKARD TINKER HOFMAN CHANCE BROWN STEINFELDT OVERALL NEEDHAM FOXEN

The Cubs 1910 squad, despite the disappointing World Series performance against the Athletics, had once again posted the best ERA (2.51) and most shutouts (27) in the National League. Their hitting was getting back into stride, too, as the team's .268 batting average was the Cubs' highest in seven years. One must go back to Adrian "Cap" Anson's 1897 club to match their league-leading 34 team home runs. The Cubs entered the World Series as favorites, but Connie Mack's Athletics clipped them in five games. Although the Cubs continued to field strong teams for the next several years, the days of Frank Chance's dynasty were over.

6

DECLINE

1911–1913

By 1911, the Cubs were visibly an aging team as well as a changing one. Orval Overall had retired, and Jack Pfiester was released early in the season after losing four decisions. In June, Johnny Kling was traded to the Boston Nationals, soon to be renamed the Braves. Harry Steinfeldt was replaced at third base by Jim Doyle, who would succumb to a fatal illness over the winter. Frank Chance appeared on the diamond less and less, as rookie Victor Saier began to supplant him at first base. Johnny Evers, enduring a nervous breakdown, played in only 44 games, with Heinie Zimmerman being stationed at second base for most of the season. While Zimmerman was a better hitter then Evers, he could not hold a candle to Evers as a fielder, which weakened the infield and placed a greater burden on Joe Tinker.

Nevertheless, the Cubs were still a strong ball club and a solid contender. Zimmerman dominated the team in batting. On June 11, 1911, he set a club record, which stands to this day, as he drove home nine runs with two singles, a triple, and two home runs in a 20-2 mauling of Boston at West Side Grounds behind Len "King" Cole. Now beginning to hit his stride, Zimmerman batted .307 for the year to pace the club.

On August 7, 1911, Joe Tinker enjoyed what he regarded years later as his greatest day in baseball. The Giants were in town as Mordecai Brown and Christy Mathewson squared off at West Side Grounds. In four times at bat against Mathewson, Tinker singled twice, doubled, and tripled, driving in four runs and scoring three. He also stole home once and executed two double plays. Best of all, Tinker's tie-breaking double in the bottom of the eighth inning drove in Zimmerman and Archer for an eventual 8-6 win for Brown, who was on his way to his sixth straight 20-win season. The following morning, the *Chicago Tribune* remarked that "Tinker broke all his own records for breaking up games with New York."

However, the New Yorkers ultimately had the last laugh, winning their first flag in six years with a 99-54 mark as the Cubs finished second at 92-62, 7.5 games off the pace.

The graceful decline of the Cubs empire continued in 1912 as they slipped to third with a 91-59 log, 11.5 games out as McGraw's Giants won an easy pennant with 103 wins and a 10-game margin over the second-place Pirates. On April 12, 1912, Tinker, Evers, and Chance appeared together as a unit for the last time as the Reds edged the Cubs, 3-2, at the river city during the second game of the young season. Chance took himself out of the lineup the following day for health reasons and did all of his managing from the bench thereafter. The double play combination was now Tinker to Evers to Saier.

Another sign that the Cubs were growing old could be seen in the output of Brown and Ed Reulbach. After eight years in double-figure victories, Brown fell to 5-6, pitching just 89 innings. Although going 10-6, Reulbach was frequently out of the rotation due to increasing arm problems.

If there had been a "Comeback Player of the Year" award in those days, Evers would have been the prime candidate for the honor. Rebounding from a broken leg and a nervous breakdown, Evers came through with a career year, batting .341 with 163 hits. Now that Evers was back at second base, Zimmerman was moved to third, where he was no better defensively than he had been at the keystone sack. On the other hand, in the hitting arena, he exceeded all expectations as his sizzling .372 average gave the Cubs their first batting champion since Adrian "Cap" Anson in 1888. It was a monumental performance, capped by a 23-game hitting streak from April 14 through May 14.

On a more ominous note, Chance was still having contract problems with owner Charles Murphy. Their relationship, never warm to begin with, was rapidly deteriorating to the point of no return.

The finale came during the City Series with the White Sox. After the first two contests had been called as ties because of darkness, the Cubs took a 3-1 lead. The White Sox then won the next three to win the Chicago championship. In the final game, they pummeled the Cubs, 16-0, behind the spitball hurling of Ed Walsh. This humiliation gave Murphy the perfect excuse he needed to fire Chance, and he did so without hesitation. Two days later, the Peerless Leader left the scene of his greatest triumphs in bitterness and recrimination.

Soon after Chance's departure, Murphy named Evers as manager. Although Evers and Tinker had now been on good terms again for several years, Tinker was still leery about having Evers as his boss and asked to be traded. In December 1912, he was dealt to Cincinnati, where Brown would join him in a short while. Just before the new season began, Jimmy Sheckard was sold to the Cardinals. Four fan favorites had disappeared in a few short months, as resentment against Murphy's cost-cutting tactics was smoldering.

The appointment of Evers as field boss was an unsettling move, both to Evers and those under his command. With additional duties thrust upon him, the Crab became crabbier than ever. Al Bridwell, the new shortstop, almost came to blows with the apprentice manager on the diamond. Outfielder Tommy Leach had several run-ins with Evers and once came in from center field threatening to rearrange Evers's face. Zimmerman was fined for "back talk." And unable to harness his volatile temper, Evers was ejected by the men in blue numerous times.

Larry Cheney, 26-10 the previous season, was again the ace of the pitching staff with 21 wins. Bert Humphries, a pitcher obtained in the Tinker trade, went 16-4 to lead the league with an .800 percentage. Left-handed pitcher Jim Vaughn, obtained in mid-August via the trade route, showed great form with a 5-1 record, a 1.45 ERA and two shutouts. Unfortunately, he was not used as often as he should have been because he and Evers did not get along. Veteran Reulbach was dealt away in mid-season. After an absence of three years, Overall attempted a comeback but retired for good after going 4-4.

It was the home run bats of Saier, Schulte, and Zimmerman that gave the dwindling number of fans at West Side Grounds their biggest thrills. The Cubs smashed 59 home runs for the season, second to Philadelphia's 73. Their long ball prowess inspired Ring Lardner to pen "The

Thumping Trio" in the *Chicago Tribune* of September 23, 1913. The ode never gained the attention of the Franklin P. Adams poem and is all but forgotten today, nor could it make the Cubs finish any higher than a distant third at 88-65, 13.5 games behind McGraw's Giants, who won their third straight pennant.

The postseason was virtually an instant replay of 1912. After the White Sox dispatched the Cubs in the City Series in six games, Murphy made Evers the scapegoat and fired him as unceremoniously as he had terminated Chance a year earlier. Murphy's shabby treatment of Chance and Evers proved to be his undoing as league officials pressured him into selling the club to a group headed by Charles Thomas and Charles P. Taft, half-brother of the former U.S. president.

Victor Saier joined the Cubs as a rookie in 1911, heir to Frank Chance's throne at first base. Saier enjoyed good seasons in 1912 and 1913, batting .288 both years, but failed to live up to expectations thereafter. Adept at hitting the long ball, he belted 14 home runs in 1913, 18 in 1914, and 11 in 1915. Saier's five career homers off Christy Mathewson were the most that the Giants' ace ever surrendered to one player. (Brace.)

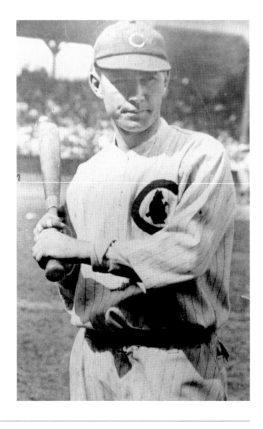

Rookie Cubs third baseman Jim Doyle poses for the camera at the home ballpark in 1911. He showed promise, batting .282 in 130 games that season. Tragically, Doyle's career came to a premature end when he succumbed to appendicitis in February 1912.

Johnny Kling's days as a Cub were numbered when this image was taken on the road early in the 1911 season.

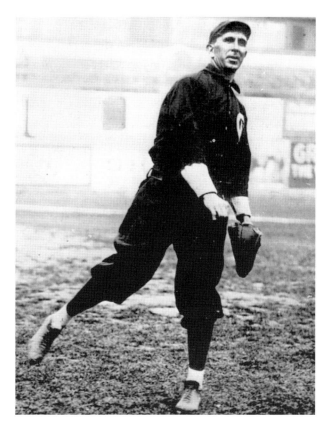

Captured here are Mordecai Brown and Frank Chance—both approaching the twilight of great Cubs careers—with their wives in 1911.

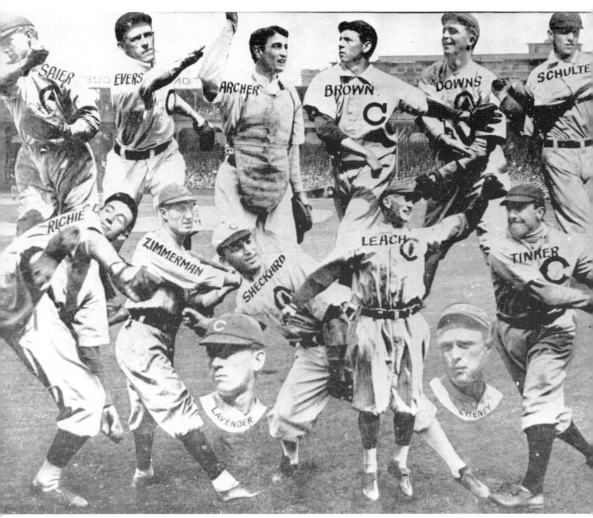

The 1912 Cubs, seen here in this rather unusual montage, finished third in the standings with a 91-59 record, 11.5 games behind the first-place Giants. After appearing in just two games at the start of the year, Frank Chance retired as a player. His relationship with owner Charles Murphy continued to sour along with his health. On September 28, 1912, while Chance was in a New York hospital undergoing surgery for a blood clot in his head, Murphy denounced his players as a bunch of drunkards and carousers who did not win the pennant because of their nocturnal habits. He also declared that future contracts would include an abstinence from alcohol clause. When Chance recuperated, he defended the players while calling Murphy a liar and a cheapskate who was milking the club. Furthermore he said that if he returned as manager in 1913 there would be no prohibition rules. Chance was dismissed as manager at season's end.

CHICAGO CUBS

Johnny Evers takes the field somewhere on the road sometime after 1910, looking as grouchy as ever.

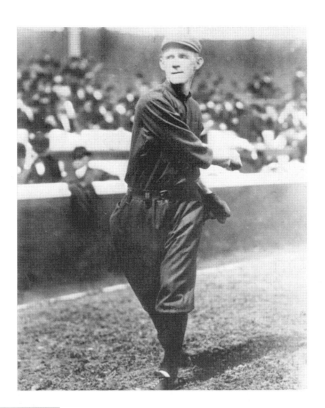

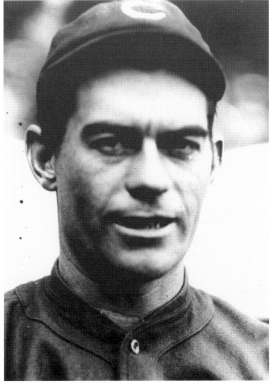

Jimmy Lavender, Cubs spitball pitcher from 1912 to 1916, is recalled for two outstanding performances. On July 8, 1912, he halted Giants pitcher Rube Marquard's record-winning streak at 19 games with a 7-2 victory at West Side Grounds. For an encore, Lavender twirled a 2-0 no-hitter against the Giants at the Polo Grounds on August 31, 1915. Like most throwers of the spitball, Lavender had control problems and despite these peaks was just a fair pitcher overall. (Brace.)

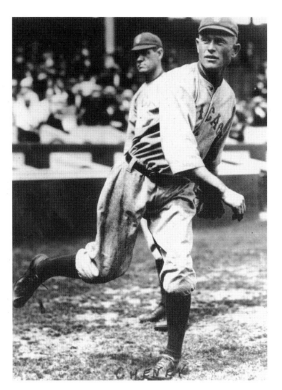

Another spitballer, Larry Cheney assembled one of the finest rookie seasons ever as a member of the Cubs in 1912, with 26 wins and only 10 losses. His 28 complete games led the league, while his win total was exceeded by only the Giants' Rube Marquard. On September 14, 1913, in the midst of a 21-win season, he shut out New York, 7-0, despite allowing 14 hits. Cheney won another 20 games the following year but slipped badly in 1915 and was shipped out to Brooklyn late in the season. (Brace.)

An aging Brown loosens up in his road uniform in 1911 or 1912.

CHICAGO CUBS

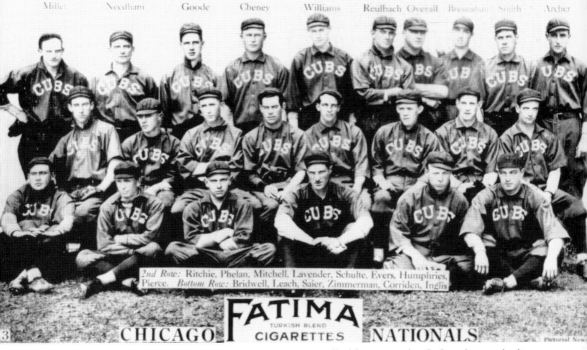

2nd Row: Ritchie, Phelan, Mitchell, Lavender, Schulte, Evers, Humphries, Pierce. *Bottom Row:* Bridwell, Leach, Saier, Zimmerman, Corriden, Inglis

CHICAGO **FATIMA** TURKISH BLEND CIGARETTES **NATIONALS**

The 1913 Cubs, managed now by Johnny Evers, again pulled home in third place but with three fewer wins than the year before. The team was frequently called the Trojans because their new field boss was a native of Troy, New York. Evers was not the only one having umpire problems. In mid-June 1913, Heinie Zimmerman set a dubious record by getting thrown out of three games in a five-day period. Finally a generous but frantic fan, using the *Chicago Tribune* sports staff and umpire Bill Klem as intermediaries, gave Zimmerman half of a $100 bill, promising him the other half if he would refrain from getting the heave-ho for two weeks. Zimmerman kept his cool and received his payoff, but the reform was short-lived. On September 13, 1913, National League president Thomas Lynch suspended him for a week for swearing at umpire Bill Byron two days earlier. Nevertheless, Zimmerman—when he was playing—was still productive as his .313 average and 95 RBI paced the club. Victor Saier had a fine season also, batting .288 with 14 home runs, 93 runs scored, and 92 driven in. In addition, he legged out 21 triples to lead the league and tie Frank Schulte's club record, which was set two years prior.

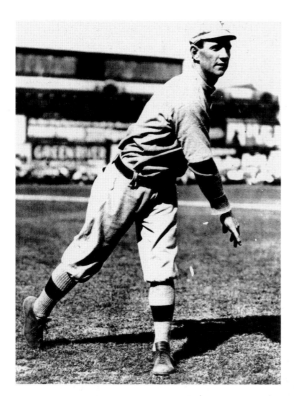

Pitcher Bert Humphries, seen here in his early days with the Phillies, had one great year with the Cubs in 1913. He went 16-4 for a sizzling .800 won-lost percentage to lead the league. However, Humphries was a one-year wonder who, by 1915, was gone from the Cubs as well as the majors. (Brace.)

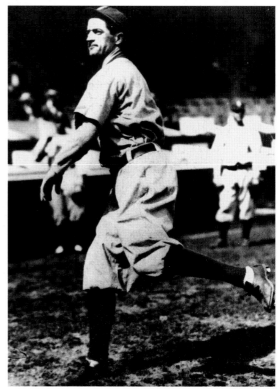

George Pearce was a left-handed spitball pitcher who won 13 games as a Cubs rookie in 1913 and again two years later. (Brace.)

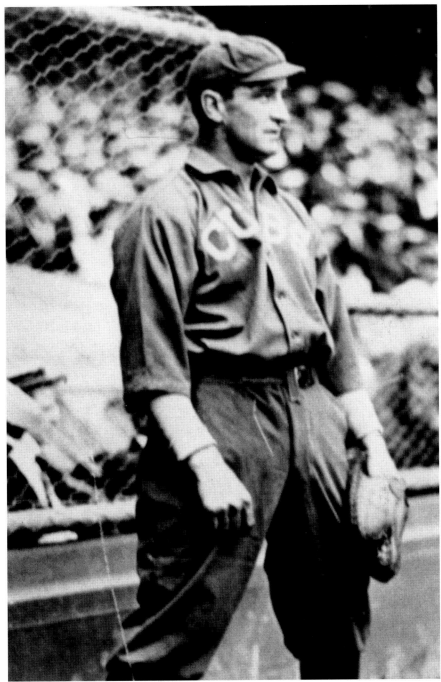

Cubs catcher Jimmy Archer, pictured here in 1913, was a light hitter—.250 lifetime with a high of .283 in 1912—but more than compensated with his defensive skills. Archer invented the snap throw from the squatting position. In 1912, with this unorthodox approach, Archer alone nailed 81 would-be base thieves. Archer was a Cub from 1909 through 1917 but was frequently injured and appeared in 100 or more games only three times (1911–1913).

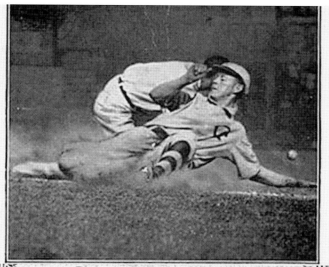

ANK L. CHANCE

rank L. Chance
ed the Chicago Na-
als in 1898. Made
ager in 1905, in
5, 1907, 1908 and
0, he led them to
National Cham-
ashio, and in 1907
1908 to the world's
nplonship also. Five
rs he batted over
. In 1910 on 814
nces he made only
e errors, the per-
age, .996, being a
d's record.

◇

ASSAN

CORK TIP

GARETTES

Evers Makes a Safe Slide

The illustration on the other side of the card
shows Johnny Evers. Chicago's famous second
baseman, making a great slide to third. He is
one of the most annoying—to the other side—base
stealers among the professionals. He takes long
leads, up on his toes all the time, doing a little
dance, and edging toward the next base. He is al-
ways a good waiter at bat, getting many bases on
balls, and generally leads the batting order.
Evers was born in Troy, N. Y., in 1883, where he
still lives and is president of the John J. Evers
Association. He joined the Troy team in 1902 as
an outfielder. Then he was drafted to Chicago,
where his career is baseball history.

FACTORY N° 649 1U DIST N.Y.

◇

HASSAN

CORK TIP
CIGARETTES
THE ORIENTAL SMOKE

JOHN J. EVE

Johnnie Evers
famous second ba
of the Chicago N
als, is a native of
and went direct
the Cubs from th
1902. In 1903 he s
second one day, an
ever since been an
tive part of the
machine. He is
ally lead-off m
the batting order,
a good waiter,
fails to get first
pass, he is likely
rive on a hit.

◇

HASSA

CORK TI

CIGARETT

The Hassan Cigarette Company got a lot of mileage from combining and reusing images for
their 1912 tobacco cards. Frank Chance and Johnny Evers's card featured this great action
shot between portraits of the famous first and second baseman. The reverse side added nice
descriptions of the players and action seen on the face. The company released a Joe Tinker-Evers
card as well that was identical save for the substitution of Tinker for Chance. Tinker's image
was used again on a card featuring the aging veteran along with his apparent successor, Edgar
Lennox, who saw scarce action and was gone by the end of the 1912 season with an uninspiring
.235 batting average.

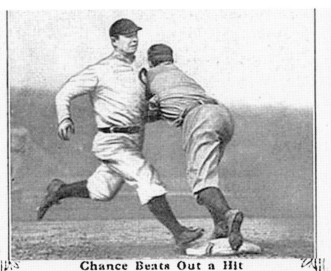

MES P. ARCHER

mmy Archer, with
famous whip, is the
s' mainstay behind
bat. He started as
ielder in Fargo, but
ng catcher's place
n with Atlanta, he
ved so well that he
made a regular
kstop. The Detroits
him in 1907, but
him go to Buffalo,
n which team the
s got him. In 1911
12 games he fielded
and batted .253.

◇

ASSAN

CORK TIP

GARETTES

Chance Beats Out a Hit

Frank Chance has just beaten out a hit, as seen
in the picture. Like most of the fans' favorites, in
private life he is one of the most retiring and un-
assuming of men; but once he gets into his base-
ball togs and on the diamond he is a hard fighter
and magnetic leader. Fresno, Cal., the land of
grapes and wine, was his birthplace in 1877. He
attended the University of Washington in that
State for a time; but the lure of the diamond got
him, and he joined the Chicago Nationals in 1899.
He has been with that team ever since. Credit is
due Chance for having landed the Cubs second in
1911, with his pitching corps shot to pieces and
his famous infield broken up.

FACTORY N° 649 ◇ 1ST DIST N.Y.

HASSAN
☒ **CORK TIP** ☒
CIGARETTES
THE ORIENTAL SMOKE

ORVAL OVERAL

Orval Overall, lat
the Chicago Nation
came to that team
1906 from Cincin
His greatest pitc
feat for them was
winning of four
consecutive victoric
the fall of 1907
spring of 1908. O
47 games won in 19
9-10, 17 were shut-o
In four years on
fielding chances
made only 11 error

◇

HASSA

CORK TIP

CIGARETTE

Cubs hurlers Orval Overall and Jimmy Archer shared a tobacco card as well. The action shot
in the middle featured Frank Chance, displaying the hustle that marked his years in a Cubs
uniform, beating out the throw at first for a hit.

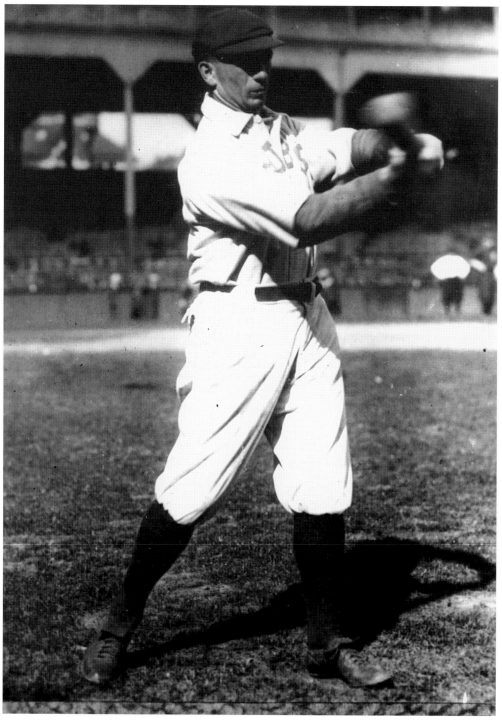

Veteran Tommy Leach was largely over the hill when he played outfield for the Cubs from 1912 through 1914. He did have a good season in 1913, batting .289 with a league-leading 99 runs scored. (Brace.)

Ring Lardner is fast at work at his trusty typewriter. Lardner, an accomplished sportswriter and satirist of the era, penned "The Thumping Trio" in 1913 as a poetic tribute to Chicago Cubs sluggers.

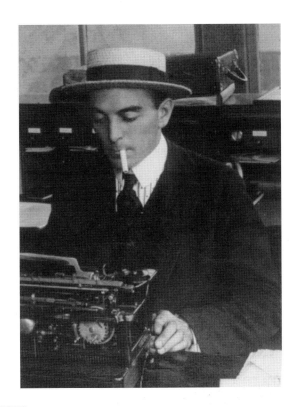

The Thumping Trio

O Mack has his Baker whose terrible blows
Spell trouble for pitchers wherever he goes.
But John has three Bakers a workin' for him
In Victor and Frank and the great Heinie Zim.

Detroit has its Crawford and also its Cobb,
Both awfully strong on the fence clearing the job.
But they're only two, just a very good pair
While Johnny has Schulte, Zimmy and Saier.

Two Phillies, Luderus and Gavvy Cravath,
Have known all along where the scoreboard was at.
But could a couple of men hope to spank
As many four baggers as Vic, Zim and Frank?

The Naps boast Joe Jackson and King Lajoie
Who wallop 'em high and some distance away.
But their list of homers look feeble and sick
Compared with the output of Frank, Zim and Vic.

'Twas close unto Yuletide one evening late
And Callahan sat as his desk by the grate.
Composing a letter, "Dear Santa", wrote Jim
"please bring me a Shulte, a Saier and a Zim."

"You've sure got some ballpark", to Commy I said.
"I'd trade it", he murmured "and trade it real quick
For a trio like Henery, Francis and Vic."

Here is Lardner's poem "The Thumping Trio." The players Lardner got to know while covering the Cubs and White Sox between 1908 and 1919 provided the inspiration for the nominally fictitious characters of the baseball stories that made him nationally famous.

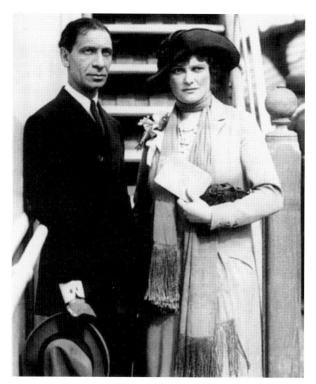

Franklin P. Adams, author of "Baseball's Sad Lexicon," is seen here with his wife in roughly 1912. The verse was at least partially instrumental in getting the threesome of Joe Tinker, Johnny Evers, and Frank Chance elected to the hall of fame as a group in 1946.

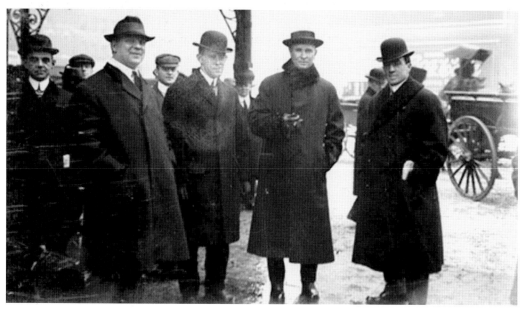

Wearing the flat-topped hat is Chance, flanked by Evers (left) and Tinker (right) at an unknown location in 1913. Putting to rest the myth that Tinker and Evers were no longer on speaking terms, all three Cubs greats are seen together in street clothes during the only year each was a big-league manager. Evers managed the Cubs, Chance the Yankees, and Tinker the Reds. That might even be a smile on Evers's face.

And Fall

1914 – 1916

Somewhat ironically, Johnny Evers was replaced as Cubs manager for 1914 by Hank O'Day, the umpire who monitored the "Merkle's Boner" game of September 23, 1908, in which Evers had played a key role. By now, the only players left from the 1910 flag winners were Jimmy Archer, Frank Schulte, Heinie Zimmerman, and third-string catcher Tom Needham. The downward spiral of the Cubs was accelerating in a major way, as the loss of Evers left the entire infield north of first base leakier than a sieve. Bill Sweeney committed 35 errors at second base, Red Corriden 46 at shortstop, and Zimmerman 39 at third, plus another 10 when he was subbing at short. Right fielder Wilbur Good pulled 20 miscues to lead all National League outfielders. Altogether the once impenetrable Cubs defense was charged with 310 errors, third worst in the league.

The team's hitting was off as well. Victor Saier would never fulfill the promise he had shown in 1912 and 1913, while the slumping of Archer and Schulte did not help either. Zimmerman still led the Cubs in batting with .296, but it was a far cry from his lofty 1912 dream season.

By far the most pleasing aspect of the 1914 Cubs was the pitching of Jim "Hippo" Vaughn, who posted a 21-13 ledger with 165 strikeouts and a 2.05 ERA. Larry Cheney won 20 but lost 18, as opposing batters began to catch on to his saliva-soaked offerings and were waiting him out. His 140 walks and 136 runs were both league highs. Beyond Vaughn and Cheney, the staff was inconsistent at best.

In spite of their glaring weaknesses, the Cubs had a good first half and as late as July 21 were in second place with a 48-37 record. But once the "dog days" of August set in, the team's slipshod infield and lack of pitching depth brought about the inevitable decline. By season's end they were lucky to finish fourth with a 78-76 mark. After years of being spoiled with contending teams, the fans stopped going to West Side Grounds. The Cubs' home paid attendance of 202,516 was their lowest in 22 years. With Cubs managers now going in and out on a revolving-door basis, O' Day was himself given the pink slip.

In 1915, catcher Roger Bresnahan became the third in a succession of one-year managers for what would be the Cubs' final season at West Side Grounds. Although the team again pulled in fourth, it was with a lackluster 73-80 record for their first finish below .500 in 13 years. Furthermore, they were only three and a half games out of the cellar since the bottom five teams were squeezed close together. Batting and defense were again essentially the same as they had been the previous year. Vaughn was in the groove again at 20-12, but the only other regular with a winning record was George Pearce with 13-9.

Attendance remained low on the West Side Grounds as fans abandoned the Cubs for the pennant-winning Chicago Whales of the Federal League, managed by former Cub Joe Tinker and the second-place White Sox. In addition to having superior teams, the Whales and the White Sox also offered new, state-of-the-art ballparks with brick and steel grandstands. The Whales' Weeghman Park, located at the northeast corner of Clark and Addison Streets, was the first (and still only) major-league enclosure on the city's North Side.

For the Cubs, it was a dull season and an unexciting team. Even so, there were several events of historical significance. On June 17, 1915, Zip Zabel, an otherwise obscure hurler, set a major-league record by pitching 18 1/3 innings in relief during a 19-inning, 4-3 victory over the Brooklyn Dodgers at West Side Grounds. Exactly a week later, Heinie Zimmerman pulled a daring two-out steal of home in the bottom of the ninth inning to give the Cubs a come-from-behind 14-13 win over the Cardinals, also at the home park. On August 18, Wilbur Good became the only Cubs player to steal second, third, and home in the same inning (the sixth) during a 9-0 shellacking of the Dodgers at Brooklyn. Finally Jimmy Lavender pitched a no-hitter to the Giants, 2-0, at the Polo Grounds on August 31.

During the winter of 1915–1916 the Federal League, often called the "Flapjack League" by its detractors because so many of the club owners were in the restaurant or baking business, folded after just two seasons on the major-league scene. Former Chicago Whales owner Charles Weeghman then purchased controlling interest in the Cubs, bringing Tinker with him to manage the team, along with several players. Among the minority stockholders was chewing gum magnate William Wrigley, who invested in a $100,000 share on January 20, 1916. With his purchase of the Cubs, Weeghman relocated them to his North Side Park, now known as Wrigley Field. At that time, it was a single-decked park with a seating capacity of 14,000.

The Cubs' first game at the new site was an 11-inning nail biter on April 20, 1916, in which the Cubs edged the Reds, 7-6, on Saier's game-winning single. Although an exciting victory, it was not a harbinger of glad tidings to come. Weeghman thought that the infusion of his better players from the Whales would make the Cubs an instant contender. The opposite happened instead.

The Whales' leading pitcher of 1915, George McConnell, had tossed 25 wins against 10 losses for a .714 percentage, tops in the Federal League. As a Cub in the new season, he went 4-12 and would never pitch in the majors again. Mordecai Brown, 17-8 for the 1915 Whales, fell to 2-3 upon his return to the Cubs. In his case, the decline was due more to advancing age—he was now pushing 40—than anything else. Mike Prendergast was 14-12 with the previous year's Whales but only 6-11 for the 1916 Cubs.

The position players fared little better. Edward "Dutch" Zwilling batted .286 in 150 games as an outfielder for the 1915 Whales. In his first and only season as a Cub he appeared in 35 contests, batting an anemic .113. He is only remembered for having the last name alphabetically on the Cubs' all-time roster. Outfielder Max Flack was the 1915 Whales' leading hitter at .314. With the 1916 Cubs, Flack dropped to .258 but would have some fine years with them in the future. Les Mann, another fly chaser, dropped from .306 with the Whales to .272 on the Cubs, while his RBI production was slashed in half, from 58 to 29. This was the best performance that any of the former Federal Leaguers came up with for the 1916 Cubs. As for Tinker, he played in but seven games and did nearly all of his managing from the bench.

The Cubs ended up a poor fifth with a 67-86 record, their worst since the disastrous 1901 campaign. Although the team was a disappointment, Cubs fans did take a liking to the new ballpark. The paid attendance of 454,609 was more than double the 1915 total.

On September 4, 1916, Tinker watched from the dugout as Brown faced Christy Mathewson, now with the Reds, in the afternoon game of Labor Day doubleheader at Weeghman Park. In a game bearing little resemblance to their tight duels of a decade earlier, Mathewson outlasted Brown, 10-8, as both left the field exhausted. Since it was the final game either would ever pitch, it symbolized the end of an era. When Tinker was released a month later, the time of "Tinker to Evers to Chance" was gone forever.

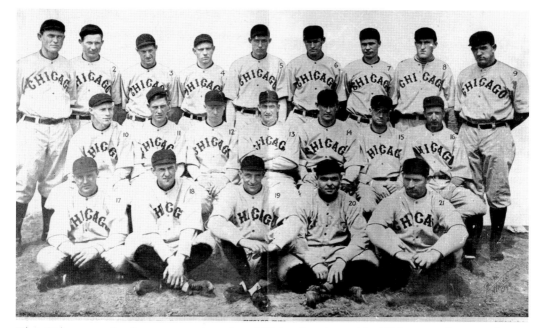

The Cubs were clearly a team going downhill by the time this 1915 team photograph was taken in their road uniforms. Catcher Roger Bresnahan, their third in a succession of one-year managers, brought the team home in fourth with a mediocre 73-80 record. It was the Cubs' first losing season in 13 years.

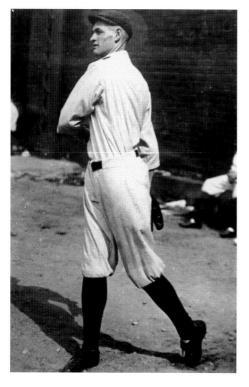

Cy Williams played outfield for the Cubs from 1912 through 1917 but was a regular only during his final three seasons. He did lead the league in home runs in 1916 with 12, only to be traded to the Phillies in 1917, thereafter becoming one of the league's premier sluggers.

The smiling Roger Bresnahan's best years were behind him by the time he joined the Cubs in mid-1913. He had previously played with Chicago briefly—one game—in 1900. Released as player-manager after the 1915 campaign, Bresnahan was later named to the hall of fame in 1945, based largely on the claim that he invented the shin guard.

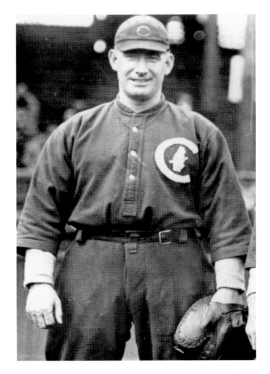

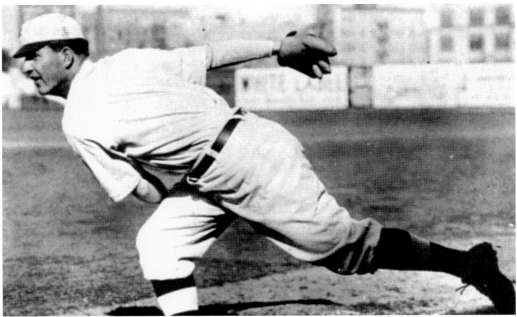

Cubs hurler Jim "Hippo" Vaughn began his major-league career in 1908 but came into his own when joining the Cubs late in 1913. He was a 20-game winner in 1914 and 1915, the club's final two seasons at West Side Grounds. Vaughn is actually best remembered for a game he lost; on May 2, 1917, at Weeghman Park, he and the Reds' Fred Toney dueled through nine hitless innings—both teams—before Cincinnati eked out two safeties in the 10th inning to win, 1-0.

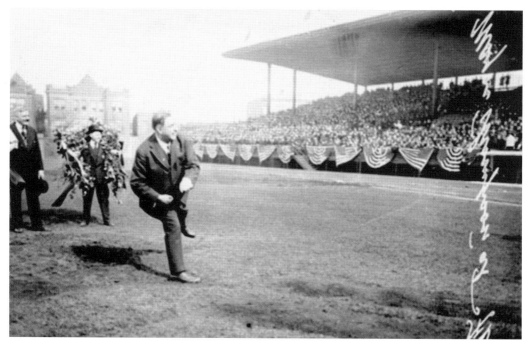

Chicago mayor William Hale "Big Bill" Thompson fires the ceremonial first pitch for the Chicago Whales home opener at Weeghman Park in April 1915.

Chicago Whales player-manager Joe Tinker (center in straw hat) and owner Charles Weeghman (at Tinker's left) are surrounded by a group of youthful fans called the Wide Awake Club at Weeghman Park in 1915.

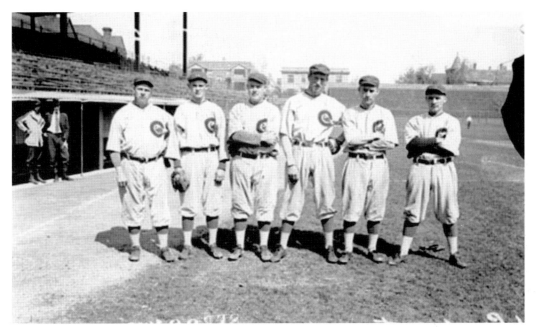

The Chicago Whales had had a good run, winning the 1915 Federal League pennant. In 1916, with the third major circuit folding, their home ballpark at the corner of Clark and Addison Streets would have new tenants, the Chicago Cubs.

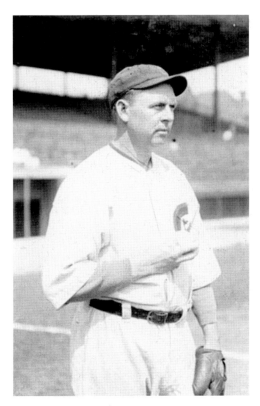

Here is Mordecai Brown in his 1915 Chicago Whales uniform. Along with several other players, Brown followed manager Tinker back to the Cubs the following season.

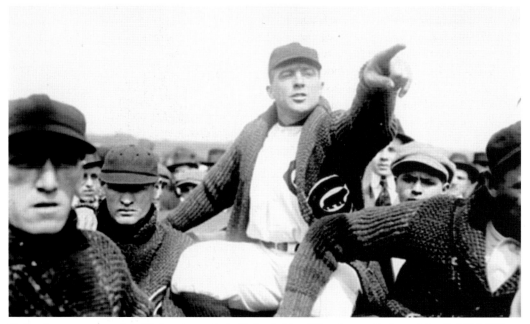

Cubs player-manager Joe Tinker is carried off the field at Weeghman Park on May 8, 1916. When the Federal League folded after the 1915 season, Whales owner Charles Weeghman purchased the Cubs and took Tinker and several others with him and moved the National League team into his new ballpark at Clark and Addison Streets.

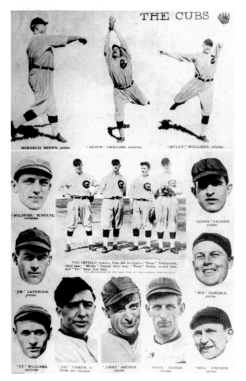

The 1916 Cubs, in Tinker's only year as manager, finished a poor fifth at 67-86. It is no wonder that Tinker (bottom row, second from left) has such a glum look on his face. Tinker's 1,500 games at shortstop in a Cubs uniform was a record unbroken until Don Kessinger surpassed it in 1975. Tinker owned a saloon in Chicago and tended bar during the off-season, and later made frequent stage appearances, earning good reviews from the theatrical press.

CHICAGO CUBS

Wilbur Good played outfield for the Cubs from 1911 through 1915 but was a regular only in his final two years with the team. On August 8, 1915, he became a footnote in history as the only Cubs player to steal second, third, and home in the same inning during a 9-0 whitewash of the Dodgers. (Brace.)

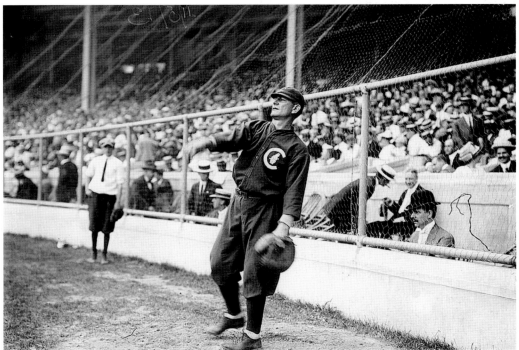

Tom Needham was a backup catcher for the Cubs from 1909 through 1914, when he saw a mere 17 at-bats in nine games played behind the plate.

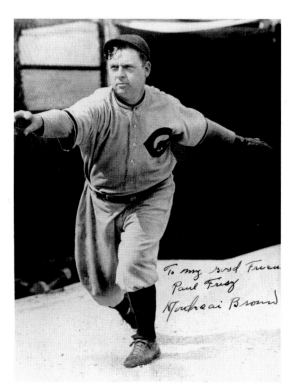

Now approaching age 40, Mordecai Brown warms up at Weeghman Park during his swan song season of 1916. The three-finger magic was gone by then, as he went only 2-3 for the year.

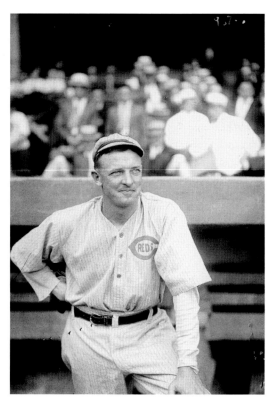

Brown's archrival, an aging Christy Mathewson, is seen as a member of the 1916 Cincinnati Reds.

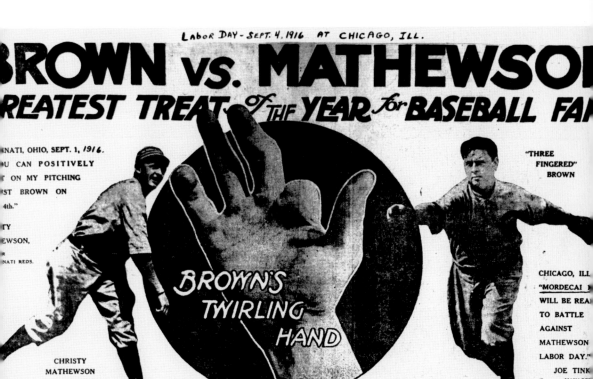

BROWN vs. MATHEWSON

GREATEST TREAT OF THE YEAR for BASEBALL FAN

CINNATI, OHIO, SEPT. 1, 1916.

"OU CAN POSITIVELY

T ON MY PITCHING

RST BROWN ON

4th."

TY

EWSON,

NATI REDS.

BROWN'S TWIRLING HAND

CHRISTY MATHEWSON

"THREE FINGERED" BROWN

CHICAGO, ILL

"MORDECAI"

WILL BE REA

TO BATTLE

AGAINST

MATHEWSON

LABOR DAY."

JOE TINK

MANAGE

- 1916. -

Game 30 P.M. | **DOUBLE HEADER LABOR DAY** | First at 1:30

WEEGHMAN PARK

OF MANY YEARS TO PITCH FOR CHICAGO CUBS AND CINCINNATI REDS

NORTH CLARK AND ADDISON STREETS.

THE DAILY NEWS BOYS BAND WILL RENDER MUS

This advertisement appeared in the *Chicago Daily News* to promote a match-up of Mathewson—then player-manager with the Reds—and Brown of the Cubs on September 4, 1916. Both pitchers were hit hard as Mathewson survived Brown in a 10-8 Cincinnati victory at Weeghman Park. It was a far cry from the low-scoring duels of their heyday and the last time either one of them would pitch, a meeting of two faded stars truly symbolizing the end of the "Tinker to Evers to Chance" era in Chicago baseball.

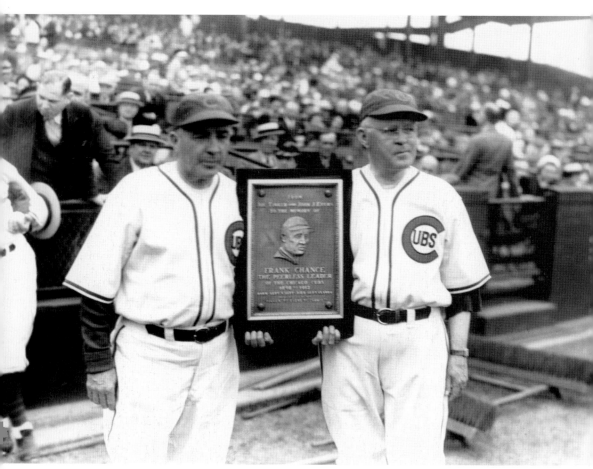

An aging Joe Tinker and Johnny Evers pose with a memorial plaque dedicated to Frank Chance at Wrigley Field in June 1937. Chance died in 1924. Evers would pass on in 1947 and Tinker in 1948. (Brace.)

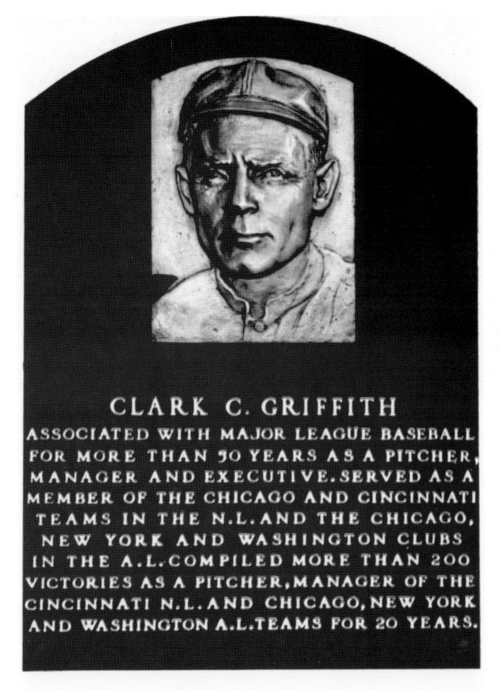

CLARK C. GRIFFITH
ASSOCIATED WITH MAJOR LEAGUE BASEBALL
FOR MORE THAN 50 YEARS AS A PITCHER,
MANAGER AND EXECUTIVE. SERVED AS A
MEMBER OF THE CHICAGO AND CINCINNATI
TEAMS IN THE N.L. AND THE CHICAGO,
NEW YORK AND WASHINGTON CLUBS
IN THE A.L. COMPILED MORE THAN 200
VICTORIES AS A PITCHER, MANAGER OF THE
CINCINNATI N.L. AND CHICAGO, NEW YORK
AND WASHINGTON A.L. TEAMS FOR 20 YEARS.

NATIONAL BASEBALL HALL OF FAME & MUSEUM
Cooperstown, New York

Here is the hall of fame plaque for Clark Griffith.

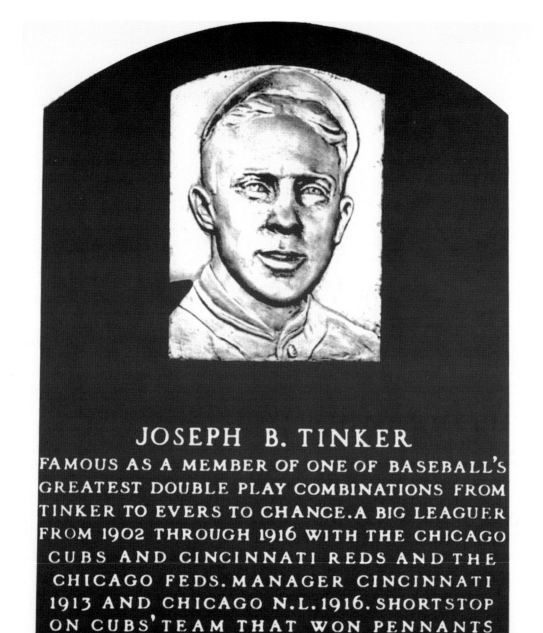

JOSEPH B. TINKER

FAMOUS AS A MEMBER OF ONE OF BASEBALL'S GREATEST DOUBLE PLAY COMBINATIONS FROM TINKER TO EVERS TO CHANCE. A BIG LEAGUER FROM 1902 THROUGH 1916 WITH THE CHICAGO CUBS AND CINCINNATI REDS AND THE CHICAGO FEDS. MANAGER CINCINNATI 1913 AND CHICAGO N.L. 1916. SHORTSTOP ON CUBS' TEAM THAT WON PENNANTS IN 1906, '07 '08 AND 1910.

NATIONAL BASEBALL HALL OF FAME & MUSEUM
Cooperstown, New York

Here is the hall of fame plaque for Joe Tinker.

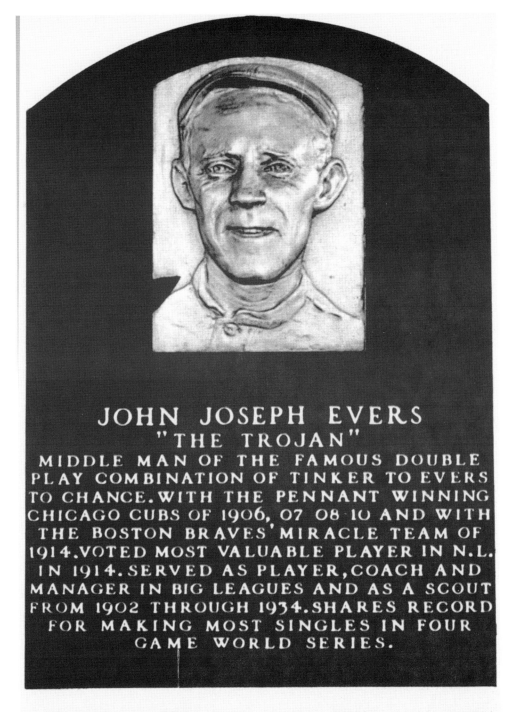

JOHN JOSEPH EVERS
"THE TROJAN"
MIDDLE MAN OF THE FAMOUS DOUBLE
PLAY COMBINATION OF TINKER TO EVERS
TO CHANCE. WITH THE PENNANT WINNING
CHICAGO CUBS OF 1906, 07 08 10 AND WITH
THE BOSTON BRAVES' MIRACLE TEAM OF
1914. VOTED MOST VALUABLE PLAYER IN N.L.
IN 1914. SERVED AS PLAYER, COACH AND
MANAGER IN BIG LEAGUES AND AS A SCOUT
FROM 1902 THROUGH 1934. SHARES RECORD
FOR MAKING MOST SINGLES IN FOUR
GAME WORLD SERIES.

NATIONAL BASEBALL HALL OF FAME & MUSEUM
Cooperstown, New York

Here is the hall of fame plaque for Johnny Evers.

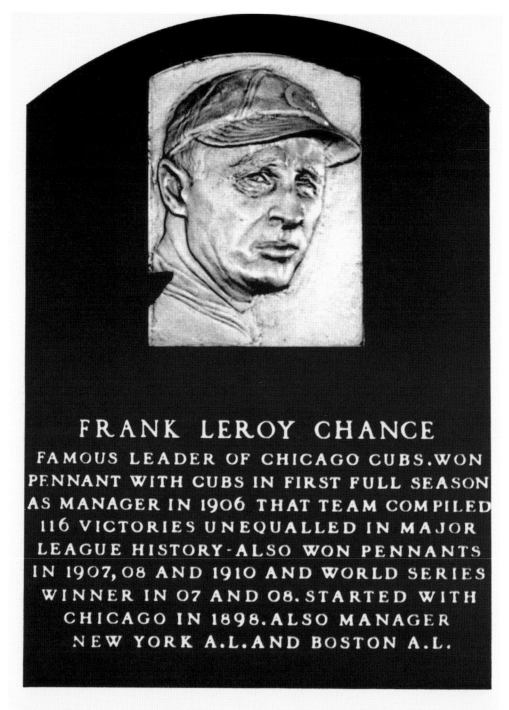

FRANK LEROY CHANCE

FAMOUS LEADER OF CHICAGO CUBS. WON PENNANT WITH CUBS IN FIRST FULL SEASON AS MANAGER IN 1906 THAT TEAM COMPILED 116 VICTORIES UNEQUALLED IN MAJOR LEAGUE HISTORY - ALSO WON PENNANTS IN 1907, 08 AND 1910 AND WORLD SERIES WINNER IN 07 AND 08. STARTED WITH CHICAGO IN 1898. ALSO MANAGER NEW YORK A.L. AND BOSTON A.L.

NATIONAL BASEBALL HALL OF FAME & MUSEUM
Cooperstown, New York

Here is the hall of fame plaque for Frank Chance.

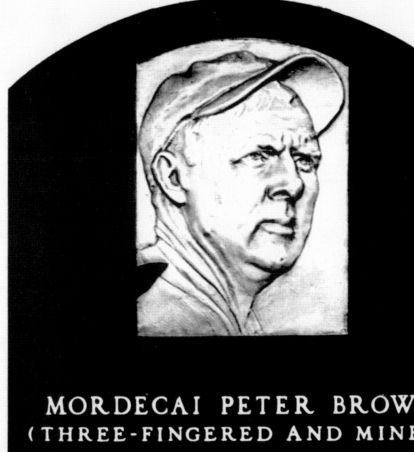

MORDECAI PETER BROWN
(THREE-FINGERED AND MINER)
MEMBER OF CHICAGO N.L.CHAMPIONSHIP
TEAM OF 1906,'07,'08,'10.A RIGHT HANDED
PITCHER,WON 239 GAMES DURING MAJOR
LEAGUE CAREER THAT ALSO INCLUDED
ST.LOUIS AND CINCINNATI N.L.AND CLUBS
IN F.L.FIRST MAJOR LEAGUER TO PITCH
FOUR CONSECUTIVE SHUTOUTS,ACHIEVING
THIS FEAT ON JUNE 13,JUNE 25,JULY 2
AND JULY 4 IN 1908.

NATIONAL BASEBALL HALL OF FAME & MUSEUM
Cooperstown, New York

Here is the hall of fame plaque for Mordecai Brown.

ACROSS AMERICA, PEOPLE ARE DISCOVERING SOMETHING WONDERFUL. THEIR HERITAGE.

Arcadia Publishing is the leading local history publisher in the United States. With more than 3,000 titles in print and hundreds of new titles released every year, Arcadia has extensive specialized experience chronicling the history of communities and celebrating America's hidden stories, bringing to life the people, places, and events from the past. To discover the history of other communities across the nation, please visit:

www.arcadiapublishing.com

Customized search tools allow you to find regional history books about the town where you grew up, the cities where your friends and family live, the town where your parents met, or even that retirement spot you've been dreaming about.